D0922878

# THE
# WATERCOLOR
# PAINTER'S
## QUESTION & ANSWER BOOK

# THE
# WATERCOLOR
# PAINTER'S
## QUESTION & ANSWER BOOK

## A N G E L A   G A I R

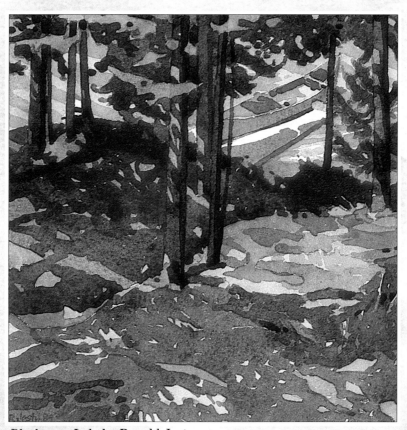

*Blackstone Lake* by Ronald Jesty

CHARTWELL
BOOKS, INC.

A Quarto Book

Copyright © 1988, 2003
Quarto Publishing plc

Published by Chartwell Books
A Division of Book Sales, Inc.
114 Northfield Avenue
Edison, New Jersey 08837
USA

ISBN 0-7858-1740-9

QUAR.WCS

This book was produced by
Quarto Publishing plc
The Old Brewery
6 Blundell Street
London N7 9BH

Printed in Singapore by Star
Standard Industries Pte Ltd

# CONTENTS

# *Introduction*

*It's easy to see why watercolor painting is so popular. To begin with, there's the sheer pleasure of physically handling such a fluid and responsive medium. There is something calming and therapeutic about watching your brush glide across the surface of the paper like a skater on ice, leaving behind it a drift of color that glistens momentarily, then settles into the fibers of the paper and dries with a luminous inner light.*

*Watercolor is also a highly expressive and versatile medium. Just as a short poem can say more than a thousand words, a good watercolor is capable of capturing all the glories of nature, of light and sun and air and mist, with just a few brief strokes. It is the unique freshness and immediacy of watercolor that appeals to the artist and viewer alike.*

*On the minus side, the fluid and transparent qualities that make watercolor so attractive also make it the least controllable and the most unpredictable of the painting media. Things can get pretty hairy sometimes, and you'll need your wits about you when your sky wash suddenly takes off in all directions or develops streaks and runs for no apparent reason.*

*In addition, painting in watercolor requires a high degree of planning and forethought. With an opaque medium such as oils, you can build up the paint in layers, applying light colors over dark ones and obliterating mistakes by painting over them. But because watercolors are transparent you can't paint a light color over a dark one as the darker color will show through. This means that you have to know in advance which areas of the picture are going to be light and which are going to be dark, and be prepared to work methodically from "light to dark," cutting around those areas which you want to leave as bare paper. If you don't plan things carefully, you may lose control of the painting.*

*Little wonder, then, that people regard watercolor as a kind of "Mata Hari;" her seductive charms are many, but if you make a wrong move you could find yourself in big trouble! It's for this reason that so many people are encouraged to work in watercolor, only to end up frustrated and disappointed when things don't work out quite as they had planned. The problems arise when the enthusiastic but untutored beginner sets out to produce a "good painting," without first getting to know how the*

medium behaves and what it is capable of. Also, it's difficult to spot the mistakes in our own work until it is too late (although it's always easy to see mistakes in someone else's painting!) because we are so involved in the painting process that we cannot step back from it and evaluate it objectively.

The aim of this book is to help you identify the problems in your own work and to provide logical solutions to those problems. For ease of reference I have divided the book into three sections: Color, Composition and Problem Subjects. Within each section I spotlight a wide range of painting problems. In each case, the problem is demonstrated in a typical beginner's painting and the solution is demonstrated in a painting done by a more experienced artist. The "beginner" paintings are intended only to demonstrate the kind of mistakes that an inexperienced painter could make. I mean no offence to those readers whose level of ability is greater than that demonstrated in these paintings.

Some of the painting problems highlighted are technical ones, to do with mixing and applying the paint. Others are less specific, and deal with how to interpret a subject, how to create a particular mood, and so on. Art is not an exact science, and there is no one, ready-made answer to any painting problem. Where appropriate, I have illustrated some solutions with the work of several different artists, each of whom has a different approach. I hope you will find these paintings inspiring, and that you will use them as starting points for your own creative solutions to painting problems.

Thomas Alva Edison once declared that "Genius is one per cent inspiration and ninety-nine per cent perspiration." For "genius" read "painting." Not only must we learn the techniques of applying the paint to the paper, but also we must learn how to look at things with a seeing eye. This may be a "problem and solution" book, but it will not guarantee you instant results. Constant practice is the only way to get results; and if you ever become discouraged, remember that for every masterpiece there is a stack of discarded "failures." But it is through our failures that we learn and discover something new that we can carry over to the next picture.

*Sketches of Rhododendrons* by Clarice Collings

# Color

Color mixing in watercolor can be both fascinating and frustrating. Sometimes magical things happen, other times a color will turn to mud for no apparent reason. This section deals with the practical problems involved in controlling such an unpredictable medium as watercolor and shows you how to avoid the pitfalls of both muddy color and weak, washed-out color. In addition you'll discover how to improve the vibrancy of your colors by mixing them wet-in-wet or applying them in transparent glazes.

Apart from the practical business of mixing pigments, this section also looks at the creative use of color and shows you how to control color relationships to create better paintings.

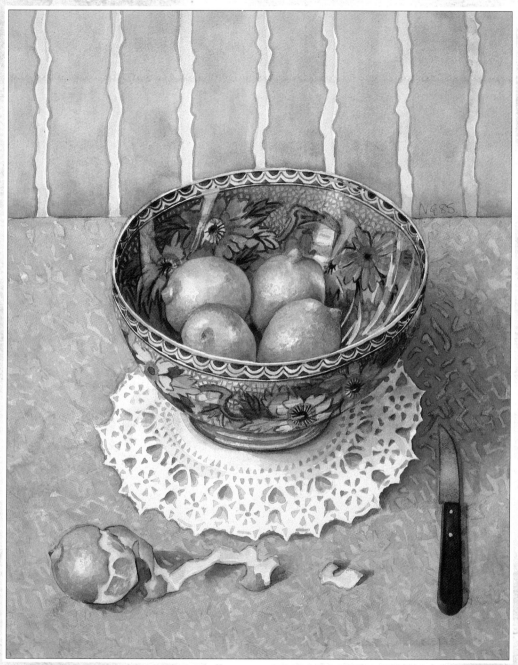

*Lemons in a Bowl* by Nicola Gresswell

# *I*'d love to be able to paint wet-in-wet, but I find the paint difficult to control.

## THE PROBLEM

In watercolor, there is no more thrilling sight than that of big, soupy washes of color being brushed onto a sheet of sparkling white paper and allowed to diffuse softly together. The effect is magical and, to me, wet-in-wet washes are the very foundation of watercolor painting.

Yet so many beginners miss out on all this fun because they are afraid that they won't be able to control wet washes. Instead they sit, tight-lipped and hunched over the page, making dry little marks with dry paint on dry paper. And then they wonder why their watercolors don't *look* like watercolors!

The landscape above is a case in point. It's pretty enough, but with its pale, anemic colors and over-careful brushstrokes, it's not about to set the world on fire.

## THE SOLUTION

Learning to control watercolor washes can be nerve-wracking at times, but it is also exciting and exhilarating. Compare the tentative brushwork in the problem painting, for example, with David Bellamy's bold and confident handling of wet-in-wet washes in *Farm, Cwm Cywarch* (opposite). To develop your confidence in handling paint in this way, try working on larger sheets of paper than you might normally use; a too-small painting surface is often the cause of tight, constricted brushstrokes.

In *Farm, Cwm Cywarch* David Bellamy has harnessed the fluid, mercurial qualities of watercolor

and used them to express the dynamic forces of nature. In particular, note how the mist and rain sweep downward from the top of the picture, as if about to engulf the tiny farm buildings cowering at the foot of the mountains. The artist preserved the white shapes of the buildings by blocking them out with masking fluid before starting to paint. Once the masking fluid was dry, he was free to brush in fluid washes without having to worry about working around small, fiddly shapes.

When you're learning how to handle watercolor, remember the three P's: Patience, Perseverance and Practice. You'll need patience because, depending on the humidity and the type of paper you're working on, watercolor washes may dry more slowly or unevenly than you anticipate. To avoid backruns and muddy colors, you must be prepared to allow one wash to dry before adding another on top (unless you're working wet-in-wet, of course). Generally, the best time to apply a second wash is when the shine has just left the first wash. You can judge this by holding your board up to the light, horizontally and at eye level.

Perseverance will stand you in good stead, because things inevitably *will* go wrong. But, after all, the capricious nature of watercolor is part of its attraction! If you happen to make a mistake, it's not the end of the world. Learn by it, and move on to the next challenge.

The need for constant practice goes without saying. It's a good idea, for example, to try out dif-

The atmospheric effect of mist and sunlight is achieved with weak washes of cobalt blue, burnt sienna and cadmium yellow, applied wet-in-wet. The board was tilted back and forth to encourage the paint to run downward.

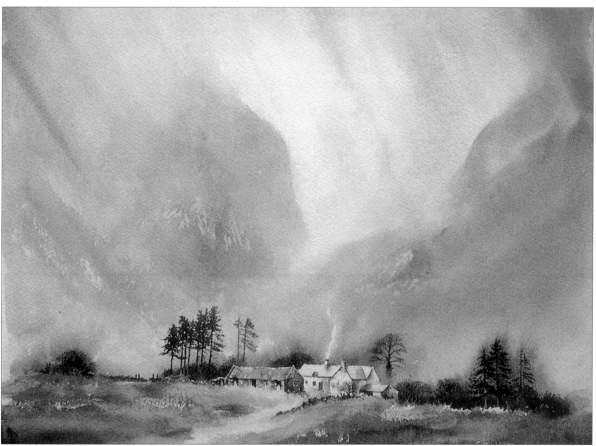

*Farm, Cwm Cywarch* by David Bellamy

The sharpest details in the picture are contained in the farm buildings, which form the center of interest.

Dry on wet strokes are used to create an impression of misty pine trees.

Here is an excellent example of how to use watercolor with controlled freedom. The flowers were painted first and carried to quite an advanced stage before working on the background. The colors – cadmium yellow middle and permanent yellow – were applied dry on wet so as to achieve soft yet still fairly precise shapes.

After wetting the background area with clean water, the artist applied his colors with loose, wet-in-wet strokes. Viridian, Winsor red, Winsor violet and permanent yellow were dropped onto the wet paper and allowed to flood into each other. The board was tilted to almost vertical at times to control the flow and direction of the paint.

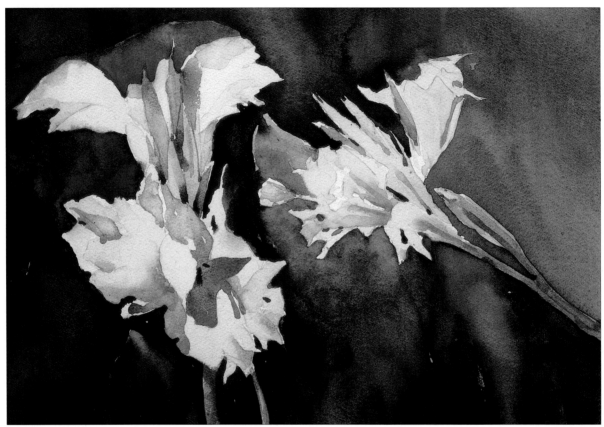

*Summer Gold* by Stan Perrott

ferent watercolor papers and test how they respond to wet washes – by scrubbing and lifting out paint, scratching out, and so on. Different papers behave in different ways, depending on what materials they're made from and on their surface coating. Your control of the paint can be helped or hindered by the absorption of the paper – something you can discover only through practice and experiment.

In watercolor there are four ways to apply paint to the paper: wet on dry; dry on dry; dry on wet; and wet on wet. Generally, you should aim to include at least two different kinds of brushstroke in a painting to give it variety and textural interest.

■ **Dry on dry** When pigment is picked up on a dry (ie just-damp) brush and skimmed lightly over dry paper, a ragged, broken stroke is created. This method, known as drybrush, can be highly expressive in suggesting rough, weathered textures or the sparkle of sunlight on distant water. Never labor drybrush strokes. Use quick, light movements. The technique works best on a medium or rough paper that helps to break up the paint.

■ **Wet on dry** Controlling shapes is easy when you apply paint to dry paper with a wet brush. The paint stays right where you put it and dries to a clean, hard-edged shape. If over-used, however, this method can make a painting look rather static and lacking in atmosphere.

Glazing, however, is a wet on dry method that will enrich any watercolor painting. When a thin, trans-

**Making marks** Simple, but infinitely variable, the four techniques shown below form the cornerstones of watercolor painting. Practice making marks like these on good quality paper and before you know it, you will have mastered the art of controlling the elusive nature of watercolor paint.

Dry on dry (drybrush)

Wet on dry

Dry on wet

Wet on wet

parent wash is applied over another, dry, color, the effect is more vibrant than when two colors are mixed together on the palette. Never attempt a glaze unless the underlying wash is bone-dry, otherwise the underwash will be disturbed and the colors will mingle and turn muddy. Always work quickly and lightly when glazing. Don't glaze more than two or three layers of color. And, finally, use only the transparent pigments, such as alizarin crimson and viridian. Opaque pigments like cerulean blue and yellow ocher are not suitable for glazing.

■ **Dry on wet** In this method a "dry" (damp) brush is loaded with pigment and applied to wet paper. The deposited pigment "swims" on the wet surface before settling into the fibers of the paper, forming a shape with diffused edges. Because the paint is relatively thick it doesn't spread too far, so you get attractive effects while retaining some control over the shapes you make.

■ **Wet on wet** Now we come to the most beautiful, the most expressive, and the least controllable method. Again the paper is wet, but this time more water is carried in the brush. The deposited pigment, being more diluted, floods out and into the wet paper and creates exciting diffusions and color interactions that you could never equal if you planned them. Of course, the potential for disaster is there too, streaks and "backruns" being the main problem (see page 14). But then, we watercolorists like to live dangerously!

# *What can I do to prevent streaks and runs forming in my watercolor washes?*

## THE PROBLEM

Handling a watercolor painting is a bit like handling a young child. Impose too much control and it will become tame and timid; exert too little control and it will run wild. In the painting above, the student has lost control of the sky wash and a huge hard-edged "backrun" has appeared in the middle of it. A backrun is a pale, circular mark with a hard, dark edge, which vaguely resembles a flower: hence it is also known as a "flower" or "bloom."

This problem occurs when a wet wash is applied over a previous wash that is only half dry. What happens is this: a brush laden with pigment and a lot of water is applied to the damp paper, and pigment and water start spreading out in all directions. Since the previous wash is still damp, granules of pigment which have not yet settled into the paper are picked up and carried with the second wash, and collect at the edges where the wash finally begins to dry.

## THE SOLUTION

The beauty of watercolor lies in its soft diffusions of color, which can only be obtained by working on wet paper. So rather than shy away from working wet-in-wet, because you've heard that it's "difficult," learn how to control mixtures of pigment and water and thus avoid problems such as backruns. Besides, watercolor is so fluid and flexible that, with a bit of cunning, you can actually capitalize on accidents and turn them to positive advantage. In *Fishing at Low Tide, Guernsey* (opposite) for example, artist

Lucy Willis has deliberately left some small backruns in the upper sky area (see detail) where they form the hard edges of cumulus clouds. Another point worth noting about this painting is the simplicity with which it is rendered. The artist has used free, spontaneous brushstrokes and allowed the washes to settle into the paper undisturbed, and this accounts for the wonderful lucidity of the painting.

However, if you don't want backruns forming in your beautiful sky wash, there are three things to remember: always wipe any excess water off your brush before picking up the paint; try to avoid working back into a wash that has not yet dried; and, if you must modify an area, wait until the previous wash is dry or almost dry. (You can judge this by holding the paper, horizontally, up to the light; if the surface looks shiny, it is still too early to apply a second wash.)

▪ **Correcting a backrun** If you do get a backrun, the situation can be saved if you act quickly enough. You can lift off the excess pigment with a piece of soft, natural sponge to form a lighter, soft-edged shape. Or you can simply paint a darker shape over it, using slightly thicker paint on an almost-dry brush. Sometimes a linear backrun will form along an edge of the paper. This occurs when a watercolor wash is overlapped onto the waterproof surface of the supporting board and starts to run back into the still-damp wash on the paper. This can be corrected by stroking over the edge with a sponge or a clean, damp paintbrush, and drying the board as well.

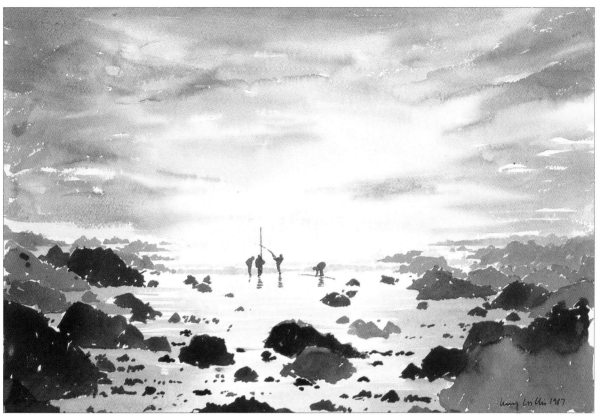

*Fishing at Low Tide, Guernsey* by Lucy Willis

If a backrun occurs in a sky wash, you can blot it out while it is still forming. Use a natural sponge (not a tissue) to lighten the area and soften the edges.

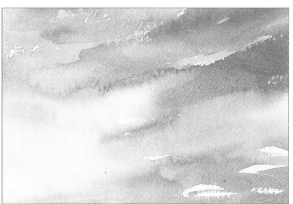

This detail from the upper right of the sky area shows how small backruns can actually be incorporated into the painting. Here they form the upper edges of cumulus clouds.

# $M$y landscape looks patchy and confused. Where did I go wrong$?$

## THE PROBLEM

If your painting looks weak or disjointed, chances are the reason is not due to lack of color contrast but lack of *value* contrast. "Value" simply refers to how light or how dark a color is. Every color, therefore, has a tonal value. Light, medium and dark values each have a different visual weight. In order to create a strong and unified image, these visual weights must be carefully planned and distributed. Think of your colors (and therefore your values) as the keys on a piano. Pressing a few carefully chosen keys will produce a rich, melodious sound. But if you spread out both hands and press keys at random, you will produce a discordant sound.

The landscape above strikes a discordant note because there is no organization to the pattern of lights and darks. Instead, the student has built up a patchwork of unrelated values and colors which fight against each other and break up the unity of the picture. This is a common mistake made by beginners, who tend to "copy" the local color of each individual object and fail to see the harmonizing effects of light on the scene.

## THE SOLUTION

The allover pattern of lights and darks is the "skeleton" that holds a painting together. It takes some time for most beginners to understand this, but once the penny drops, their work improves enormously.

Stan Perrott's painting *Farm Near Totnes* (oppo-site) actually contains fewer colors than the problem painting, yet its emotional impact is far greater. The country scene is brought to life through the contrast of light against dark, rather than color against color. The image is composed of large masses of light, dark and middle value, giving the image strength and stability. Note, for example, how the dark values of the land play against the pale value of the sky, and the pale value of the house contrasts with the dark trees behind. Compare this to the problem painting, in which the lack of value contrast makes the image seem weak and washed out, like an underdeveloped photograph.

■ **Value masses** It's important to plan the value pattern of your subject before you start painting – especially in a watercolor, which must be worked up gradually from light to dark. It's a good idea to make a small value sketch of the scene you wish to paint, indicating the main areas of light, dark and middle value. Remember to group similar values together into larger shapes – don't scatter small bits of value all over the painting.

■ **Dominance** Try never to end up with a painting evenly divided between light and dark values. Allow one or the other to dominate, or use mainly middle values with small areas of light and dark to give the image impact. Stan Perrott's painting, for instance, comprises mainly middle values, with the dark shapes of the trees and the light shape of the house providing dramatic contrast.

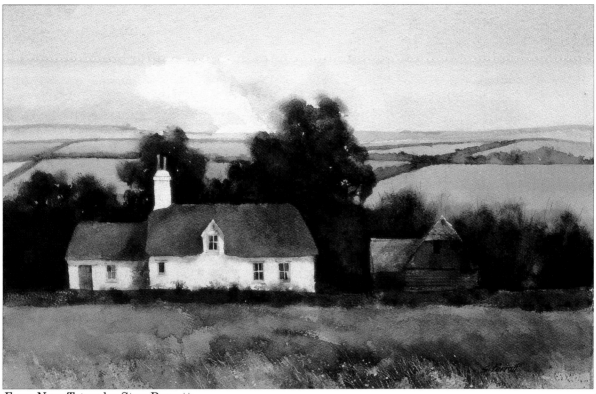

*Farm Near Totnes* by Stan Perrott

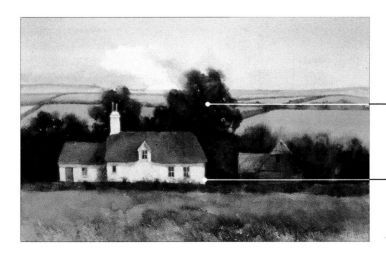

The colors and values in the background trees are simplified to give strength and stability to the image.

Here the lightest and darkest values provide dramatic impact, set against the middle values in the rest of the painting.

# *I'm fairly pleased with this painting, but it's a little tame. How can I give it more drama?*

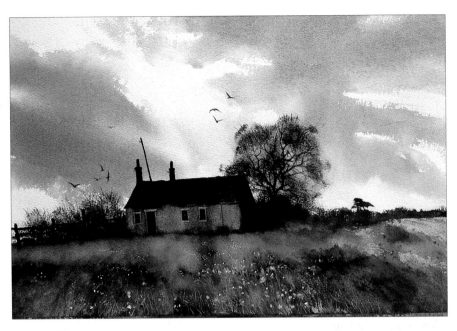

## THE PROBLEM

Often, what inspires an artist to paint a particular subject is not so much the subject itself but the way the light falls on it. Capturing the effects of light and atmosphere in a scene will communicate a mood, thus inviting the viewer to share in a unique emotional experience.

In his first version of *Storm from the Sea* (above) artist Stan Perrott painted the scene more or less as he saw it on a dull, overcast day. The colors are subdued, and the value range is basically middle-key, with few dramatic lights and darks. As a painting, it is perfectly acceptable, but the artist felt that it needed something to lift it out of the ordinary.

## THE SOLUTION

In the second version of *Storm from the Sea* (opposite) the composition is similar, yet the mood is very different. Here the artist uses a limited palette of cobalt blue, Payne's gray and burnt sienna to create dark values and colors which convey the brooding, scary atmosphere of an approaching storm. Note also how he has shifted his viewpoint slightly so that the dark shape of the cottage stands out against the light part of the sky. The clouds are now dark and menacing, and the white shapes of the seagulls add a final dramatic note.

■ **Plan the mood** The key to capturing mood and atmosphere in a painting is careful planning. The main thing to make sure of is that the colors, the values and the linear design of your painting are all consistent with the mood you want to convey. Begin by identifying the overall tonality of the scene. Does it strike you as soft and tranquil? Or light, bright and breezy? Make sketches of the scene, if necessary altering the composition and manipulating the value range until you feel that it strikes the right note.

■ **Tonal values** Controlling your tonal values is particularly important, because the relative amounts of light and dark in a painting have a strong influence on its emotional feeling. Let dark values predominate if you want to create a low-key, atmospheric mood. Let light values predominate if you want a bright, high-key mood. Always work within a limited tonal range; if there are equal amounts of light and dark in the painting, the emotional message will become dissipated.

On the next page you will find more examples of how to orchestrate the shapes, values and colors in your painting to intensify its emotional impact. Remember, as an artist you should aim not to reproduce nature, but to interpret it.

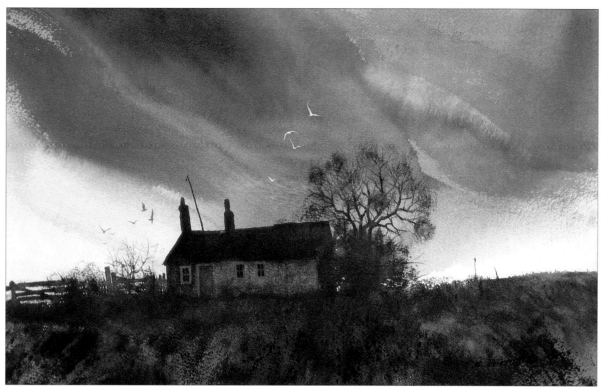

*Storm from the Sea* by Stan Perrott

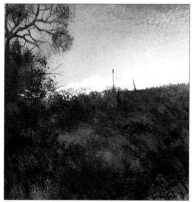

The cottage is outlined against the light part of the sky. Strong value contrasts here add impact. Dark, swirling clouds radiate from the center of the picture in a convincingly dramatic way.

The seagulls are painted with masking fluid to preserve the white of the paper before applying the sky wash. When the paint has dried, the fluid is rubbed off to reveal the birds' delicate white shapes.

Cobalt blue, Payne's gray and burnt sienna are used for the dark values of the grass, textured with scumbled brushstrokes using a hog's hair fan brush.

High-key colors and values create a strong impression of bright sunlight in this delightful beach scene. The girl's dark jumper adds a note of contrast which prevents the image looking "washed out."

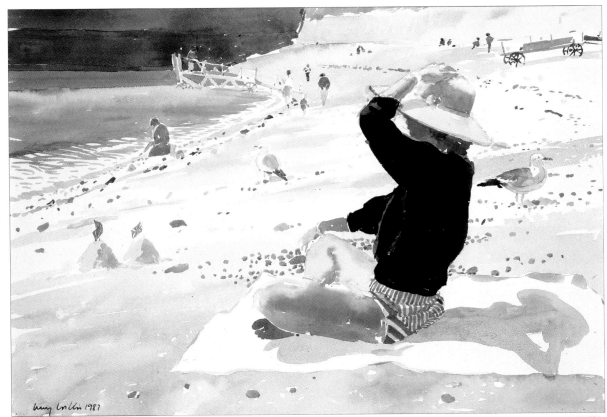

*Black Jumper* by Lucy Willis

The threatening mood of an approaching storm is conveyed here through the use of predominantly dark values. The large, looming shape of the barn heightens the tension.

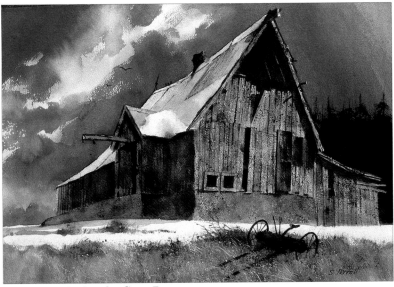

*Barn Near Ladner* by Stan Perrott

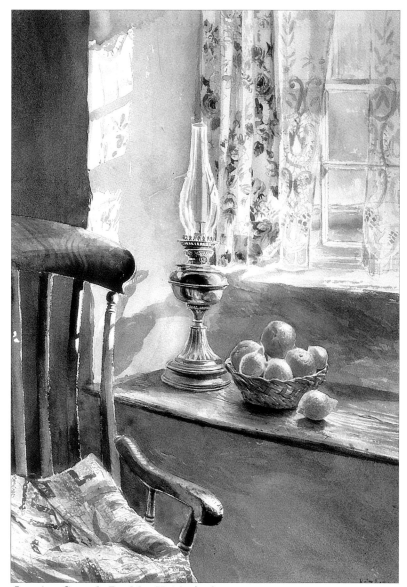

*Interior, Gwyndy Bach* by Keith Andrew

Subtle colors and soft middle
values contribute to the quiet
mood of this domestic interior.

# *T*he shadows in my painting look too strong, like dark holes in the paper.

## THE PROBLEM

It's often assumed that shadows are either black or gray, because that is how they sometimes appear at first sight. In the still life above, for example, the colors in the rest of the painting have been well thought out, yet the first thing that hits the viewer's eye are those heavy, dark shadows. They stand out like a sore thumb, destroying both the illusion of form and the effect of light.

Another factor that contributes to "dead" shadows is the way in which the paint is handled. In this example, the student has used heavy washes of flat color which almost obliterate the forms beneath.

## THE SOLUTION

In Sally Launder's painting *Salad Things* (opposite) the colorful, luminous shadows are just as exciting as the objects casting them, and the whole picture appears to sparkle with light and color.

The key to painting effective shadows, as with so many other things, lies in patient observation. Look hard enough and you will begin to see unexpected colors in even the darkest shadows. It's rather like peering into a darkened room: as your eyes adjust to the darkness, you begin to make out the shapes and colors within.

■ **Colors in shadows** The color of a shadow is determined first of all by the local color of the object in shadow. Thus the shadow side of a red apple appears a darker shade of red. But there are other factors at work, too, such as the colors of the surrounding environment and the nature of the prevailing light. On a bright sunny day, for example, a shadow's color can be influenced by the reflections of strongly colored objects nearby.

Just to make things even more interesting, colors tend to throw complementary colors as shadows, especially in bright sunlight. Thus the folds in a yellow dress may appear blue-violet, and the folds in a red dress may appear green or blue-green.

■ **Techniques** Always try to keep your shadows as luminous as possible. Think of them as a transparent veil through which the color of a surface is perceived. In watercolor this can be achieved by first painting the local color of an object, and when this is dry, applying a thin glaze of your chosen shadow color over it. Another method is to mix the shadow color and the local color of the object wet-in-wet. This creates highly attractive effects, with subtle modulations of color within the shadow.

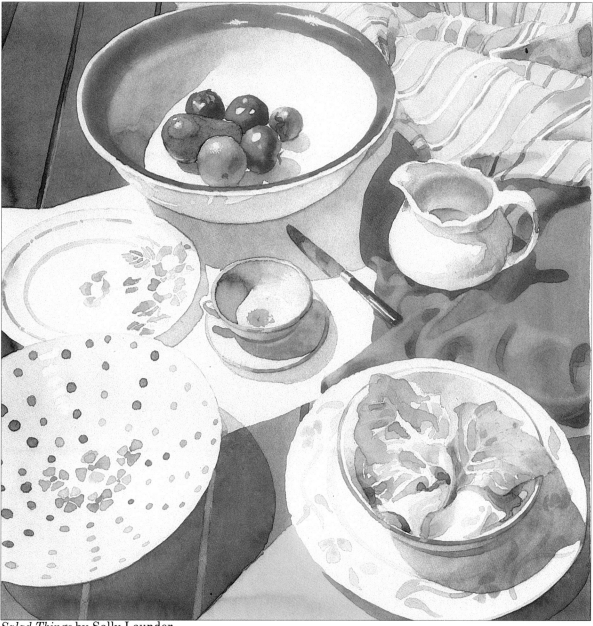

*Salad Things* by Sally Launder

This detail from the bottom right of the painting shows how a thin, transparent shadow wash can be glazed over an area without obliterating it, thus creating an impression of light and luminosity.

# *H*ow can I make the foliage greens in my landscape look more realistic*?*

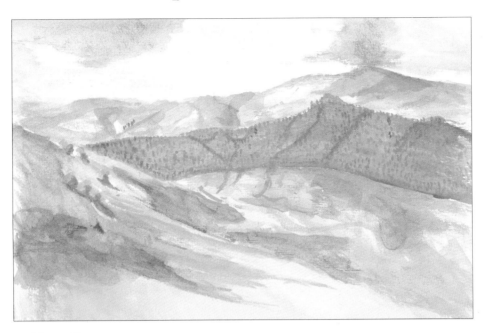

## THE PROBLEM

The lush greens of a landscape in high summer are an inspiration to any artist. But the sheer number of different greens to be found in grass and foliage can be quite overwhelming for a beginner, and it's all too easy to resort to a few hurried dabs of sap green or Hooker's green and hope for the best.

The landscape painting above illustrates the two most common faults made by inexperienced artists. First, the landscape colors have been applied straight from the tube, without any modification. They're altogether too intense, too strident – not at all like the soft greens of nature. Second, the student has tended to paint large areas of the picture with one single green, without any changes in temperature, value or texture; this leads to a rather flat, poster-like effect.

## THE SOLUTION

In *Shades of Summer* (opposite) Moira Clinch uses a more subtle and varied range of greens in the grass and foliage. Notice how the colors change gradually from warm and intense in the foreground, becoming cooler and grayer in the distance. This use of color gradation lends an impression of depth and atmosphere to the scene – something that is missing in the problem painting, in which the distant hills are of the same intensity as the foreground ones. Notice, too, how Moira Clinch has introduced positive contrasts of light and dark which enliven the picture and encourage the eye to explore the composition.

■ **Modifying tube greens** There are, of course, some splendid greens available in tubes and pans. But these used alone may not be enough to give you the flexibility required to capture the subtle nuances that are found in nature's greens. To obtain livelier, more expressive color, it's often better to vary your tube greens by modifying them with blues, reds and oranges. It's amazing how tube greens such as viridian and Winsor green, which are unnatural in appearance in their pure state, become much more lifelike when mixed with other colors. The tiniest drop of viridian, for example, when mixed with chrome yellow, produces a luminous, transparent green which is ideal for painting sunlit foliage.

■ **Do-it-yourself greens** Better still, learn how to mix your own greens, using yellows and blues, so that you can vary them from light to dark, bright to muted and warm to cool. The color-mixing chart on the next page demonstrates just some of the many possible color combinations that will give you a wide and exciting range of greens. Try making your own color chart by dividing a sheet of watercolor paper into sections. Squeeze some Prussian blue onto your palette. Mix a small amount of it with cadmium yellow, and paint a sample patch of the mixture on your chart. In the next square use Prussian blue with a different yellow. Continue in this manner, until you have mixed all your yellows with Prussian blue, labeling each sample as you paint it. Repeat the process with other blues, mixing the yellows in the same sequence as before.

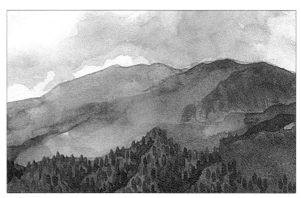

The greens become cooler and bluer in the distance, giving an impression of depth and space.

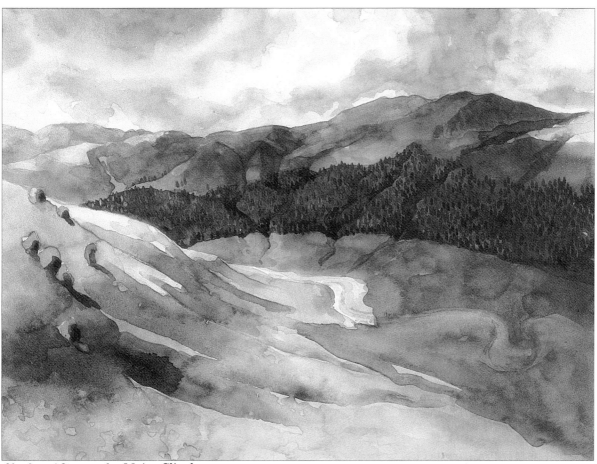

*Shades of Summer* by Moira Clinch

Here, blues and yellows are blended wet-in-wet to create lively variations of color.

*Formal Gardens* by Alex McKibbin

The greens in this landscape are fresh and vibrant because the artist has built up his colors and values with lively strokes of red, green, blue and yellow. An interesting color note here is the reddish-mauve shades in the tree trunk and branches, made with loose strokes of purple madder alizarin, ultramarine blue, terre verte and raw sienna. Red and green, being opposites on the color wheel, intensify each other when juxtaposed and here create an impression of warm sunlight.

**Mixing greens** Blues and yellows mixed together give a wide range of rich and subtle greens. Tube greens, too, can be modified with other colors on your palette. Varying the proportions of the pigments used will give you even more combinations.

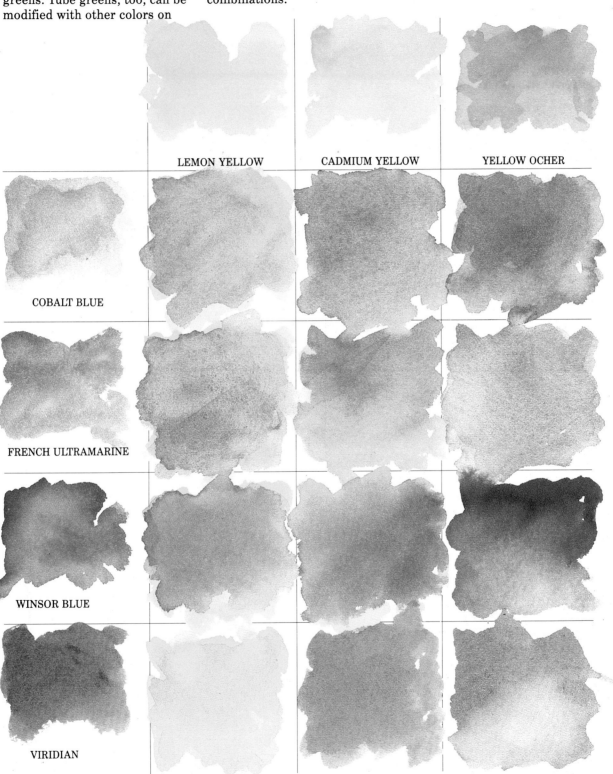

LEMON YELLOW      CADMIUM YELLOW      YELLOW OCHER

COBALT BLUE

FRENCH ULTRAMARINE

WINSOR BLUE

VIRIDIAN

# *T*his landscape looks childish and lacks subtlety. Where did I go wrong*?*

## THE PROBLEM

**J**ust as a composer chooses and arranges musical notes to produce a melodious sound, so the artist should choose and arrange his colors to create an image that is harmonious and pleasing to look at. If you put too many color "notes" in your picture, it becomes confused and "out of tune."

The beginner usually understands this point in principle, but what happens in practice is often very different. In the race to get something down, the student works in a haphazard fashion, mixing up a hotchpotch of colors on the palette and jabbing them onto the paper with no idea of how they will relate to one another once the painting is completed. There's also a tendency to paint the local colors of objects – blue sky, brown fence, and so on – while ignoring the fact that every color is affected by the harmonizing influence of the prevailing light.

The unfortunate results of this approach can be seen in the landscape painting above, in which every color screams for attention and the image appears awkward and disjointed, like a child's jigsaw puzzle.

## THE SOLUTION

**C**ompare the problem painting with Norma Wheatley's version of the scene, *Yew Tree Farm* (opposite). This painting "hangs together," with a harmony of color and value that gives it a visual continuity. The artist has used a limited palette of cool blues, grays and greens, with no jarring color notes to destroy the unity of the whole.

■ **Color dominance** The key to establishing color harmony lies in using restraint. Before you begin painting, decide whether you want your picture to be predominantly warm or cool, bright or muted. Then choose your colors accordingly and stick to these same colors throughout. Remember, the narrower the range of colors on your palette, the more harmonious your pictures will be.

■ **The influence of light** Nature is always harmonious because light touches every color and suffuses it with its own color. On a sunny afternoon, the colors in a landscape reflect the golden glow of the sun; on a cold winter's day the same landscape may take on a blue tonality. To achieve this kind of harmony in your paintings you must forget preconceived notions about what color something is *supposed* to be. Local colors are always influenced by the color of the prevailing light, so unify your color scheme by modifying the local colors of the objects you're painting with warm or cool color. In *Yew Tree Farm*, for instance, the light is decidedly cool, and the artist deliberately exaggerates this with a predominantly blue-gray color scheme. Had the scene been painted on a sunny day, she may have accentuated the impression of sunlight by introducing warm reds and yellows into the scheme. Remember, as an artist you are free to depart from the literal and alter the actual colors that you see, in the interests of making your picture work. Turn the page for further ideas on how to make your paintings sing with light and color.

*Yew Tree Farm* by Norma Wheatley

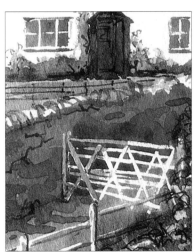

Touches of cool blue are woven through the painting, as in the foliage greens.

The color of the wooden fence is altered to white, in keeping with the cool tonality of the painting.

The pink-washed farmhouse would have upset the color balance of the painting, so the artist alters it to white, in keeping with the cool color scheme.

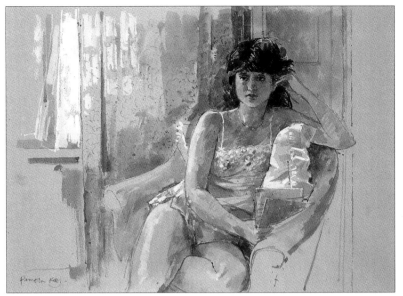

*Victoria in an Armchair Reading a Letter* by Pamela Kay

Watercolor paper is available in a wide range of hues apart from white, and many artists prefer to work on a toned support that provides a dominant color key for the painting. Here, for example, a cool buff-colored paper sets the stage for the portrait's quiet, contemplative mood. The color of the paper plays an integral role in the painting: first, it provides a harmonizing element, tying together the colors laid over it. Second, it encourages freshness and spontaneity, because fewer washes are needed to complete the image.

The surest way of establishing color harmony is by using a restricted palette of colors and weaving them throughout the image. In this portrait the artist uses an essentially monochromatic palette, consisting of tonal variations of one color. The warm pinky-browns of the child's skin are repeated in the chair and cushion, with just a few touches of neutral blue in the shadows for contrast.

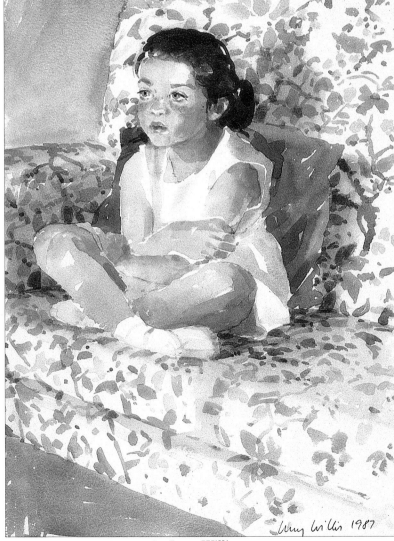

*Sarah Watching Television* by Lucy Willis

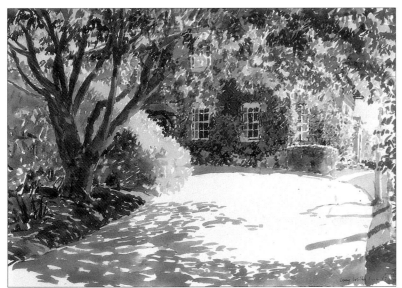

*Quintea Da Real* by Lucy Willis

Complementary colors are directly opposite one another on the color wheel, yet they can be made to work together harmoniously. The secret lies in controlling the tonal values of the colors and establishing a dominant warm or cool color scheme. In this painting, the artist uses complementary colors – red and green – to create an impression of bright autumn sunshine. The colors balance and unify each other because they are all warm in temperature and light in value.

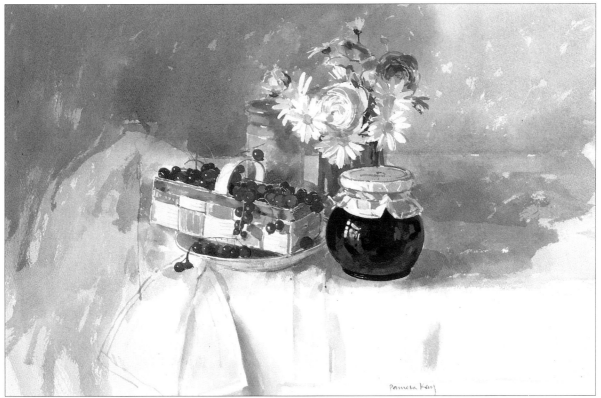

*Redcurrants and Preserves* by Pamela Kay

Analogous colors (those next to each other on the color wheel) are always harmonious because they share a common base color. For example, red-orange, red and red-violet all have the color red in common. This still life incorporates colors from the warm half of the color wheel, stretching from warm yellow through red-browns to pinks, reds, red-violet and violet. The subtle interplay of warm red-browns and cool violets in the background helps to tie the group together, while the golden yellow accents add a note of vitality.

# *How can I keep my colors from turning muddy when I mix them?*

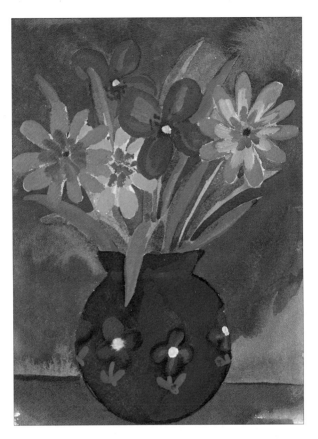

## THE PROBLEM

No other medium can quite match up to the unique freshness and delicacy of watercolor – that is, if you know how to handle watercolor properly. For the beginner it can be very frustrating when colors that sparkle like jewels on the palette end up looking like mud on the paper.

So why *do* things go wrong? Mostly muddy color is the result of muddy thinking. In an effort to make something look "real," the inexperienced painter tends to fiddle about on the paper, pushing and prodding the paint and building up dense, chalky layers of color – as is the case in the still-life painting above.

## THE SOLUTION

Compare the rather gloomy aspect of the problem painting to Richard Akerman's *Floral Arrangements IV* (opposite), which is filled with radiant light, color and excitement. Here the artist has built up his colors with thin, transparent glazes, like delicate layers of tissue paper, so that they retain their freshness and sparkle.

**White space** For some reason, novice painters usually feel compelled to cover every inch of the paper with color, yet more often than not the light-reflecting surface of the paper itself has a positive part to play in the freshness and spontaneity of a watercolor painting. In *Floral Arrangements IV*, for example, areas of untouched paper breathe air and light into the painting and accentuate the delicacy of the colors.

**Don't overmix** When mixing pigments together to create a particular color, don't be tempted to blend them so thoroughly that they become flat and lifeless. Colors *partly* mixed on the palette, so that the original pigments are still apparent, have a much livelier color vibration. Try placing the pure, unmixed pigments on damp paper and blending them just slightly so that they fuse together wet-in-wet, as Richard Akerman has done in the background to the flowers.

**Keep it clean** When pure, unmixed color is brushed onto white paper and allowed to settle undisturbed, the effect is clear and luminous. So don't prod, poke, dab or scrub your colors once they are on the paper! Be sure of the color you want before applying it, then brush it on quickly and confidently. Watercolor painting is like playing golf; the fewer strokes you use, the better.

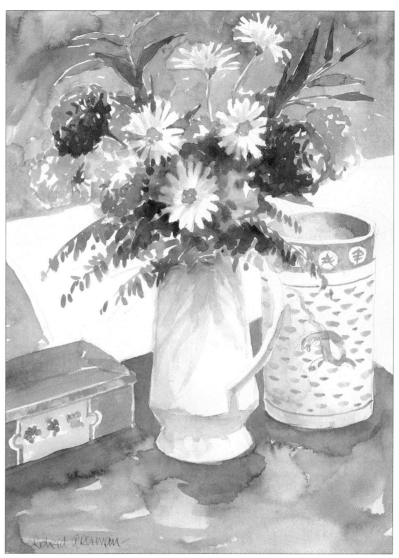

Layers of transparent color applied in thin glazes build up form without looking heavy and overworked. Areas of bare paper reflect light and act as "breathing spaces."

Pools of color mixed wet-in-wet set up warm/cool color vibrations.

*Floral Arrangements IV* by Richard Akerman

Mixing too many colors together on the palette creates dense, muddy color.

Thin, transparent glazes allow light to reflect off the paper and up through the colors, giving them greater clarity and vibrance.

# *H*ow can I portray skin tones more effectively in my portraits*?*

## ──────── THE PROBLEM ────────

**O**ur skin is translucent and has a reflective surface, its color being affected not only by the blood vessels lying beneath it but also by the quality of the prevailing light and even the colors of nearby objects. In addition, of course, skin values can vary widely from one person to another.

Faced with such a seemingly complex subject, some beginners resort to a vague approximation of what they believe to be the color of skin – usually a plain pink or brown. In the portrait above the student has painted the skin with flat, opaque washes of browny-beige, darkened with black in the shadow areas. The result is a somewhat lifeless portrait which fails to capture the marvelous translucence of human skin.

Notice also the hard, dark outline around the face, which is totally unnecessary and makes the unfortunate sitter look like a puppet.

## ──────── THE SOLUTION ────────

**C**ompare the skin values in the problem painting with those in *Portrait of Gaye* (opposite), in which Paul Osborne captures the soft, dewy appearance of young skin and conveys an impression of a living, breathing person.

The colors used here are alizarin crimson, lemon yellow and tiny amounts of ultramarine and raw sienna. But the artist doesn't mix his colors together on the palette, since this would make them go flat and lifeless. Instead, he partly mixes them on the paper with small brushstrokes, layer upon layer.

■ **Warm and cool colors** The skin appears lighter and warmer in the prominent, light-struck areas and darker and cooler in the receding or shadowed parts. Because warm colors appear to advance and cool colors to recede, you can use warm/cool color contrasts to model the "hills and valleys" of the face, much as a sculptor pushes and pulls his block of clay. In *Portrait of Gaye*, notice the subtle hints of cool blue and violet in the shadow side of the nose and under the lower lip, and the warm yellows on the forehead and cheek.

■ **Luminosity** In a watercolor portrait, light reflecting off the white paper plays a vital role in creating an impression of the skin's natural luminosity, so try to keep your colors as clear and fresh as possible. Following Paul Osborne's example, practie modeling the form of the face with small strokes of color, glazing thin layers over each other. Work on just-damp paper, so that you can blend strokes wet-in-wet in the soft areas such as the cheeks and chin.

"Lost" edges on the light-struck side of the face are more lifelike than a hard outline.

Highlights can be gently blotted out with a tissue or a damp brush to give a natural sheen to the skin. Subtle modulations of color are achieved by partial mixing.

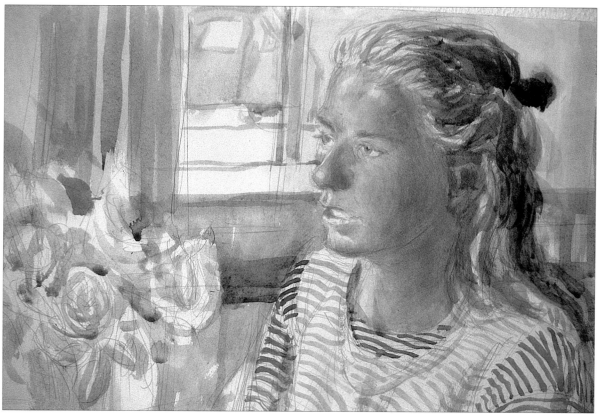

*Portrait of Gaye* by Paul Osborne

▶For pale skin tones the artist mixes alizarin crimson and lemon yellow, adding a touch of ultramarine for the cool shadow areas.

▶▶For dark skin tones, use the same colors but add a touch of raw sienna or Hooker's green.

# *M*y painting of a sunset looks garish and over-bright. Where did I go wrong*?*

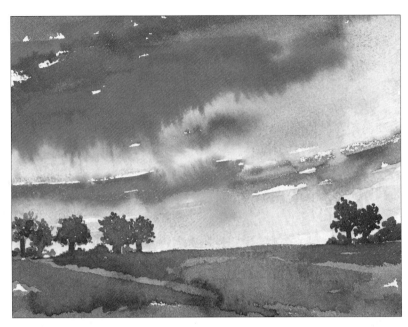

## THE PROBLEM

Sunsets, with their rich, glowing colors, have always been a popular painting subject. It's tempting, however, to go a bit overboard with the hot pinks, reds and oranges, and this can result in a corny, picture-postcard image if you're not careful.

In the painting above, for example, the colors in the sky have a "synthetic" appearance. Instead of conveying the tranquil mood that prevails at the close of day, the overall effect of this painting is somewhat jarring.

Incidentally, another common mistake is demonstrated here by the rather crude treatment of the silhouetted shapes of the trees. These dark shapes look like cardboard cut-outs – uniformly black, with hard, brittle outlines.

## THE SOLUTION

The key to painting sunsets lies in the gentle art of understatement. In *Evening, Pantygasseg* (opposite) artist David Bellamy uses colors that are much more muted than those in the problem painting, yet the impression given of light and luminosity is much greater.

■ **Warm and cool contrasts** The sky at sunset takes on a radiant glow which even the brightest pig-ment colors can never hope to match. The artist, therefore, must use cunning and skill in order to create the *illusion* of radiant light in his or her painting. One way to do this is by including both warm and cool colors in the sky, because a warm color always appears warmer and brighter when placed next to a cool color. In *Evening, Pantygasseg*, see how the artist interweaves the warm pinks and golds of the setting sun with the cool blues and violets of the clouds and the distant mountains. When we look at the painting, the warm and cool colors "vibrate" against each other and create a radiant glow. In addition, notice how the dark values of the land accentuate the brightness of the sky.

■ **Transparent pigments** When painting sunsets, use pure, clear, transparent pigments which allow light to reflect off the paper and up through the colors, thus increasing the impression of light and luminosity. Colors like cadmium red and yellow ocher should be used sparingly, because they are relatively opaque. A suitable palette of transparent colors might include vermilion or alizarin crimson, lemon yellow or chrome yellow, and cobalt blue. Subtle tints can also be mixed from these colors: for example, cobalt blue with just a hint of alizarin crimson added will give a rich, glowing violet.

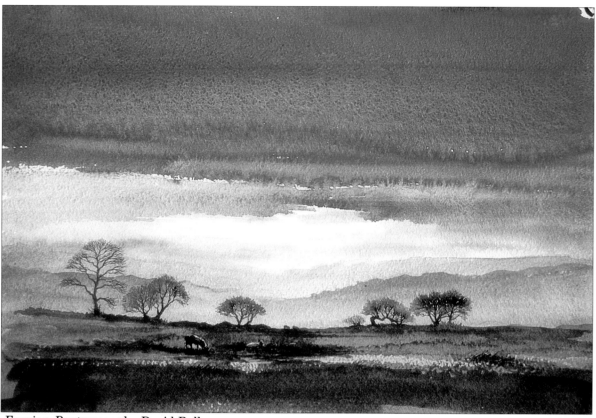

*Evening, Pantygasseg* by David Bellamy

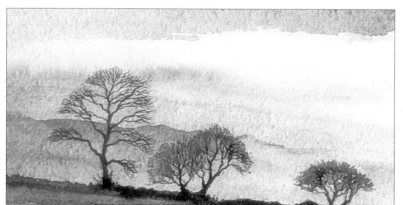

The sky and hills are painted with mixtures of French ultramarine and alizarin crimson, beginning with weak washes and working up gradually to the stronger values. The orb of the sun is indicated by a small area of untouched paper and thin washes of cadmium yellow.

The outer twigs and branches of the trees are suffused by light from the sky. This detail shows how the artist uses a lighter value for the fine outer branches and merely suggests the twigs using quick drybrush strokes.

# *H*ow can I make the sky look more luminous in my painting*?*

## THE PROBLEM

**A** clear blue summer sky may seem the simplest thing in the world to paint, but making a success of it requires a little thought.

In the painting above, the sky looks like a flat wall of blue standing behind the sea. Because it is a uniform color and value all over, it gives no feeling of atmospheric perspective, of the sky turning paler and cooler in color as it stretches back to the horizon. The actual color of the sky here is strident and unnatural because the student has used a single blue (cobalt) straight from the tube, without modifying it with other colors to make it more interesting.

## THE SOLUTION

**I**n Paul Osborne's painting *Mykonos Church, Greece* (opposite), the sky is a very pale blue, yet it sparkles with light and luminosity and contains a palpable sense of atmosphere. How has the artist achieved this effect? Let's look at the painting in more detail and see what we can learn from it.

**Gradations** The sky isn't a uniform blue all over. Due to the effects of atmospheric perspective it normally appears brightest and warmest directly overhead, becoming increasingly cooler and paler in color as it nears the horizon. In *Mykonos Church*, note how the sky softly gradates from blue at the zenith to a pale, pearly yellow close to the horizon. It is also stronger and more intense on the left of the picture, indicating that the sun is to the right, "bleaching out" the sky color around it.

To recreate this effect in your painting, try adding just a hint of red to the sky at the top to make it warmer. Lower down, begin to use cooler blues, blue-greens and yellows. The best way to achieve an even gradation of value and color is by working wet-in-wet with graded washes, as shown opposite.

**Lively colors** Resist the temptation to overblend your colors – you're an artist, not a house painter! Overblended colors look flat and dead, whereas loose brushstrokes and partly blended colors lend character and energy to a sky painting. In *Mykonos Church* the artist used a large, well-loaded brush to sweep in loose strokes of color for the sky, leaving them to settle into the paper undisturbed. The paint was kept thin and transparent, allowing the warm undertone of the yellowish paper to glow up through the blue washes. This creates a subtle, atmospheric haziness in the sky.

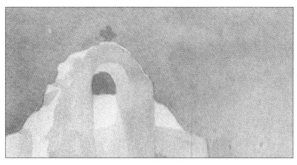

Loosely applied brushstrokes give life and movement to what could have been a flat, boring expanse.

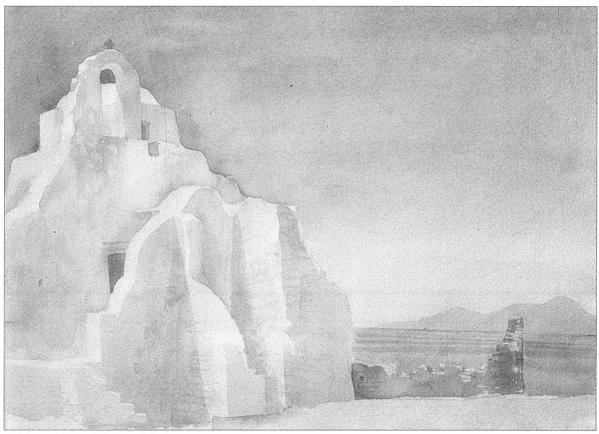

*Mykonos Church* by Paul Osborne

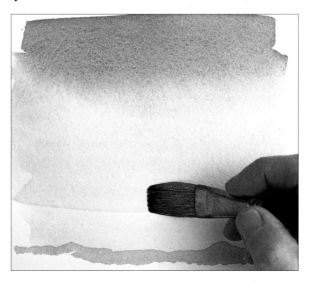

**Laying a graded wash** Tilt your board at a slight angle to enable washes to flow freely down the paper. Using a well-loaded brush, work down the page with broad sweeps of ultramarine blue, gradating it to nothing by adding more water to the paint with each successive stroke. Just before the first color dries, sweep in strokes of cobalt blue at the top of the sky to make it warmer. Leave the paper to dry in the tilted position.

# *How can I make the grays in my painting look more interesting?*

## THE PROBLEM

Gray is one of those colors, along with greens and browns, that create problems for artists, and this may be the reason why many of us resort to using ready-mixed grays in tubes. Although this is fine for small areas, when it comes to large areas a little more variety is called for. Nothing looks so monotonous as a vast area of flat, dull gray – which, unfortunately, is exactly what we have in the sky in the painting above. The same gray – made from watered-down ivory black – has been used throughout, with very little variation apart from the occasional patch of blue here and there. The stormy sky, instead of being a swirling mass of exciting color, looks like a tired gray curtain.

## THE SOLUTION

The grays in nature are never dull. Look out over the ocean, or up at a cloudy sky, and you'll see grays that are tinged with subtle hints of blue, violet, red and brown. Take a hint from nature and brighten up your grays by introducing other colors into them.

Sally Launder's painting *Storm at Sunset* (opposite) demonstrates how successful this approach can be. The storm clouds, tinged with the colors of the setting sun, are now decidedly the focal point of the picture, full of color and movement.

■ **Complementary colors** There are much more exciting ways to make a gray than by thinning black pigment with water. The most vibrant grays are made by mixing complementary colors: that is, colors that are opposite one another on the color wheel, such as yellow and violet, blue and orange, and red and green. You can also mix grays from near-complementaries such as blue and brown.

When mixed in equal amounts, complementary colors cancel each other out, creating a neutral gray. But by varying the proportions of the two colors used in the mixture – say, more red and less green – you can extend your range of grays enormously. For example, if you want a violet-gray, try mixing a warm red such as Venetian red with ultramarine (which veers towards violet). For a reddish gray, try burnt sienna and ultramarine.

You can control the temperature of a gray by varying the amount of warm and cool color in the mixture. For example, if you want a cool gray use more blue and less brown, or more green and and less red. For a warm gray, switch the proportions.

Other examples of colorful grays are shown on the next page, but there are, of course, many variations which you will discover in the course of your own experiments.

This detail from the large cloud mass shows the range of subtle blues, browns and yellows used to portray "gray" clouds.

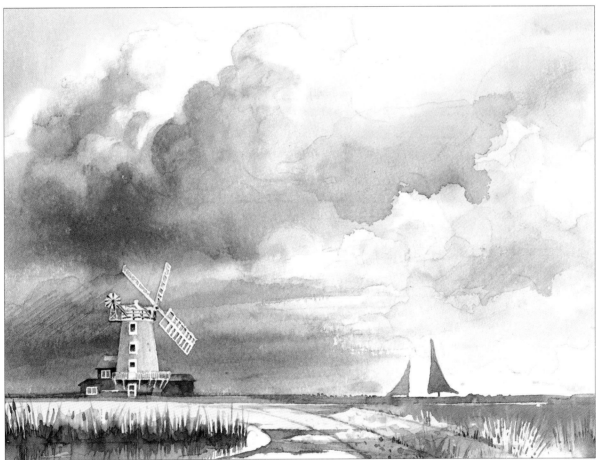

*Storm at Sunset* by Sally Launder

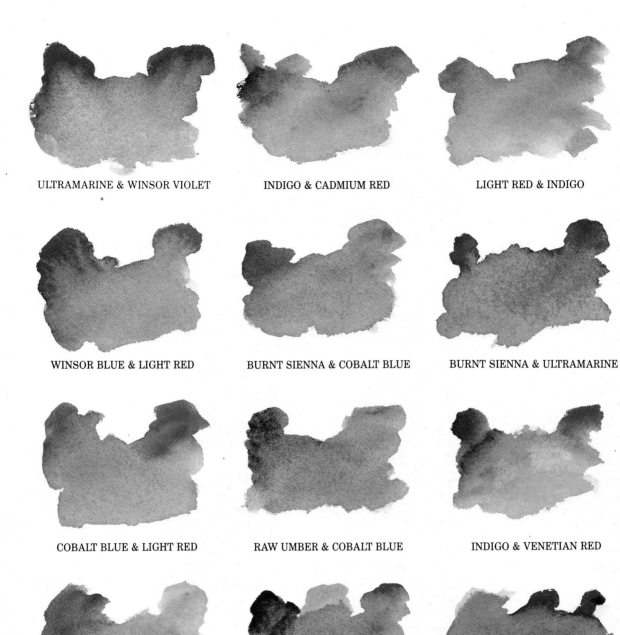

ULTRAMARINE & WINSOR VIOLET

INDIGO & CADMIUM RED

LIGHT RED & INDIGO

WINSOR BLUE & LIGHT RED

BURNT SIENNA & COBALT BLUE

BURNT SIENNA & ULTRAMARINE

COBALT BLUE & LIGHT RED

RAW UMBER & COBALT BLUE

INDIGO & VENETIAN RED

PERMANENT MAUVE & VIRIDIAN

RAW UMBER, VIRIDIAN & ALIZARIN

CHROME YELLOW, WINSOR BLUE & ALIZARIN

**Mixing grays** When mixed together, colors that are opposites on the color wheel produce lovely, vibrant grays. Mixing together the three primary colors – red, yellow and blue – also has the same effect. Varying the proportions of each pigment in the mixture opens up even wider horizons.

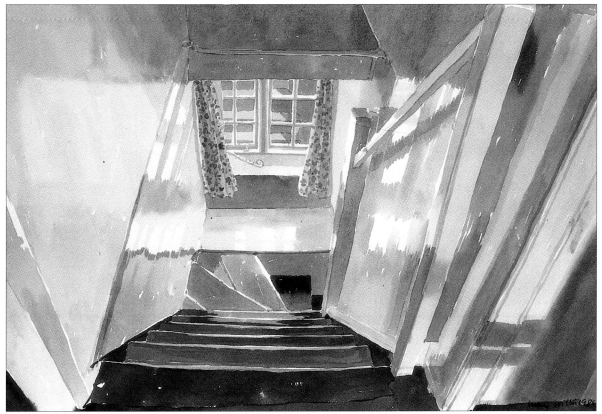

*The Staircase at Cliff Cottage* by Lucy Willis

This painting is a remarkable study, not only of perspective but also of light and color. The picture is composed entirely of grays, ranging from the palest tint to the deepest gray-brown, giving an impression of consistent, harmonious light.

# *H*ow do I capture the luminosity of white buildings in bright sunshine*?* My picture looks flat and dull.

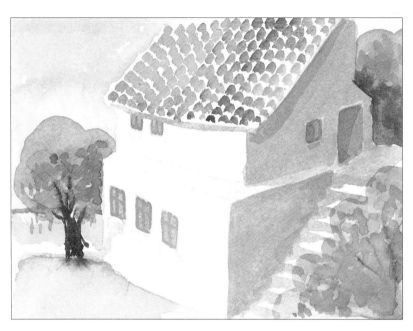

## THE PROBLEM

**O**n the face of it, painting a white building in watercolor seems easy. You just leave most of the paper bare and paint the shadow areas gray. However, as the painting above shows, this approach does not make for an interesting picture. In common with a lot of novice painters, the student is distrustful of what he actually *sees*, and paints instead what he *thinks* he sees. In this example, the shadows are a uniform gray and the sunlit side of the house is a uniform white. A white building in bright sunlight contains a surprising number of colors, but these are ignored because the student thinks, "But if I put in all these colors the building won't look white."

## THE SOLUTION

**W**hen you look at Moira Clinch's painting *Morning's Awakening* (opposite) you'll notice at once how *colorful* the building is. Much of the painting consists of blues and yellows, yet the overall impression is one of a white building under the dazzling glare of the Mediterranean sun.

■ **Reflected color** It's often difficult to detect the subtle nuances of color on the surface of a white building, particularly when harsh sunlight blinds the eyes. But it is exactly these unexpected flashes of color and reflected light that give a magical touch of luminosity to a painting. In *Morning's Awakening,* see how the stone sidewalk projects lovely pinks, yellows and violets upward onto the crumbling stonework. These warm colors contrast with the deep, cool blues of the shadows and accentuate the brilliant white light.

It's true that reflected colors are harder to see in some cases than in others. But even if a shadow looks just plain gray to you, at least analyze it in terms of temperature – decide whether it's a warm or a cool gray. Never be afraid to intensify colors just a little, if it will serve to improve the painting – although, of course, this should not be done as an affectation. Every artistic decision you make must be done for a purpose; otherwise the painting will have a hollow ring to it.

■ **Pattern and texture** One reason why the problem painting looks boring is that there is no variation in color, value or texture to break up the broad planes of the building. Compare this to the solution painting, in which the artist emphasizes the texture of crumbling stonework and the patterns of the door and window. Note, too, how the strong cast shadows add three-dimensional reality.

*Morning's Awakening* by Moira Clinch

Gradations of value give the impression of light reflecting into the shadows, whose intense blue adds to the sensation of strong sunlight.

Warm colors are projected onto the walls from the sidewalk below.

# Composition

*Composing a picture in watercolor presents its own particular problems. You have to plan things carefully in advance because you can't paint over mistakes as you can in oil paint. This section looks at a wide range of composing problems, from emphasizing a center of interest to creating depth and space in a landscape; from composing skyscapes to designing a floral still life. In addition, you'll find plenty of exciting ideas that present a fresh slant on the accepted conventions of composition, allowing you to turn an ordinary subject into a powerful visual statement.*

*Snowdrops on a Table* by Keith Andrew

# *My landscape lacks dramatic interest. Should I have composed it differently?*

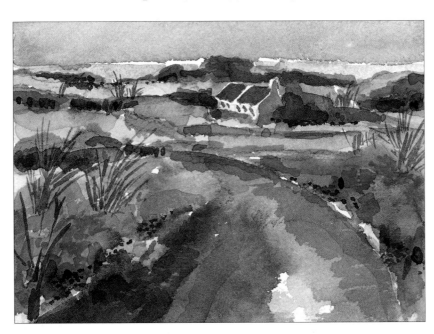

## THE PROBLEM

James McNeill Whistler (1834-1903) was right when he said, "Seldom does Nature succeed in producing a picture." What he meant was that a scene that is breathtaking to the naked eye may appear less exciting when translated into paint on a small square of paper. Often, it isn't enough simply to copy the subject in front of you; sometimes you may have to add, subtract or re-group some of the elements in the scene in order to create a more balanced image.

The problem with the landscape above is that it has no main focal point, nothing that says, "*This* is why I wanted to paint this scene." The road leads our eye into the painting, but then it turns sharp left and leads us straight out again. The cottage in the distance could have been the center of interest, but it doesn't stand out strongly enough. There is nowhere for the eye to stop and linger, so the picture is like a sentence without a period.

## THE SOLUTION

Just as a play or film often has one main character and a supporting cast, so a picture should have one focal point – that is, one spot that draws the eye and that carries the main theme of the painting – supported by shapes and colors of secondary interest. This is what gives balance and unity to the painting.

In *Road to the Sea* (opposite), note how artist Stan Perrott has made slight alterations to the composition and to the values and colors in the scene, in order to make a stronger image. The cottage in the distance is now firmly the focal point. Why? Because it is here that the lightest and darkest values in the painting are juxtaposed – and the viewer's eye is always attracted by such a strong contrast. Note also how the sweeping curve of the road now leads us to the center of interest instead of veering off out of the picture.

When planning the composition of a painting, always ask yourself, "What do I want to emphasize, and how should I emphasize it?" There are many ways to draw attention to the focal point, but they all have one thing in common: they involve the use of *contrast* to generate excitement in that area.

Choosing the focal point of your painting and planning ways to accentuate it are the keys to good design. Turn the page for more ideas on how to make your paintings more exciting and dynamic.

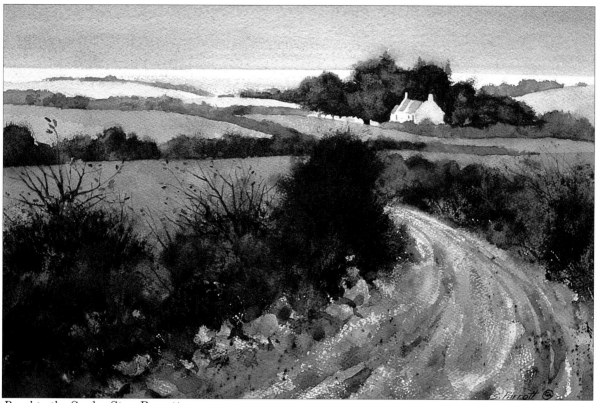

*Road to the Sea* by Stan Perrott

The contrast of the darkest and lightest values attracts the eye and forms the focal point of the picture.

Harmonious colors and values give clarity and strength to the image.

The light value of the road leads the eye to the focal point.

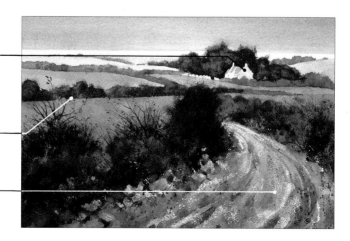

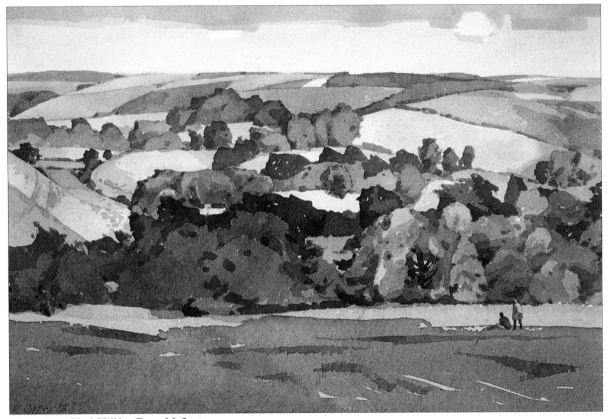

*View from Hod Hill* by Ronald Jesty

▲The eye is always drawn to human figures in a landscape, and their inclusion can turn an ordinary subject into a striking picture. Here the two figures on the right, tiny as they are, form the anchoring point for the whole composition. We look first at them; then, following their gaze, we explore the rolling landscape beyond.

▶Undoubtedly the most dynamic way to create a focal point is by contrasting the lightest and darkest values. This takes planning in watercolor because you have to paint "negatively," working around the white shapes. Here the artist painted the daisies and gypsophila with masking fluid to preserve the white of the paper, then brushed in a dark background of ultramarine and burnt sienna.

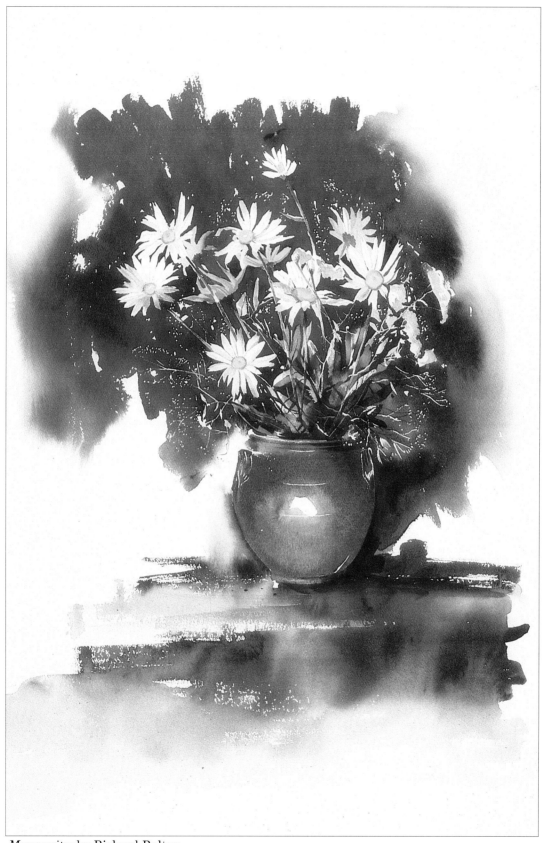

*Marguerites* by Richard Bolton

*T*his was a magnificent stretch
of scenery, yet my painting of
it looks bland and unexciting.

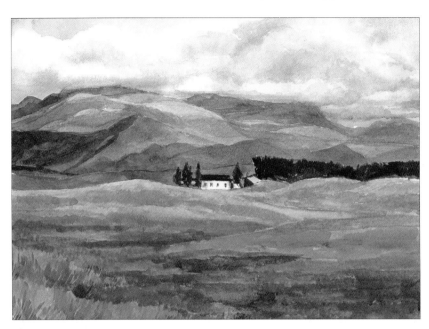

## THE PROBLEM

**O**n page 48 I talked about the necessity of having a strong focal point in a picture: somewhere for the viewer's eye to linger. Equally important – although many beginners don't realize this – is guiding the viewer's eye through the picture toward the focal point.

The landscape above is nicely painted, but it fails to excite our interest because it is too bland. To begin with, the focal point – the farmhouse – is placed slap in the middle of the picture, which is much too boring and symmetrical. And because there are no interesting directional lines leading to the farmhouse, it looks lost and disjointed.

The painting is composed of three horizontal bands: the sky, the mountains and the foreground. These have the effect of carrying the eye right out of the picture, because there are no strong vertical shapes to counterbalance the horizontals.

## THE SOLUTION

**T**o capture and hold the attention of your viewer, try to design rhythmic lines and undercurrents that flow *into* the center of interest from the edges of the picture. As the problem painting shows, the compo-sition presented by nature is not always ideal. You must choose your viewpoint carefully and be prepared to alter the arrangement of things if necessary in the interests of making a more balanced and coherent image.

In *Farm in the Valley* we have a scene similar to that in the problem painting, with a tiny cottage nestled at the foot of the mountains. Only in this version the artist, Keith Andrew, has created an exciting composition guaranteed to hold the viewer's interest.

First, the focal point (the cottage) is placed just off-center, at a point that is a different distance from each edge of the paper, thus creating balance without boredom. Note how everything is designed to lead the eye to the focal point: the mountains sweep downward from the top of the picture, while the river and the trees curve in from the bottom right. Even the clouds are designed to lead the eye down to the mountains and on to the cottage. The impression of depth is much greater, too, because the curving lines take us *into* the picture, not *across* it as happens in the problem painting. The whole picture is beautifully choreographed, yet the directional lines are subtle enough to guide the eye without being obtrusive.

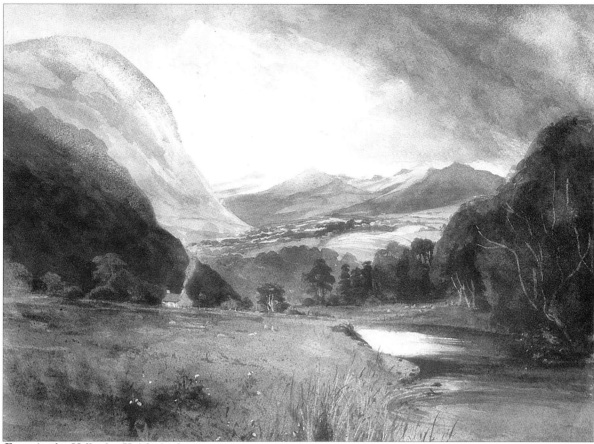

*Farm in the Valley* by Keith Andrew

The clouds pull the eye down into the painting.

The mountains form strong diagonal lines which propel the eye to the focal point.

An area of light value against dark attracts attention and so forms the focal point of the picture.

The river and trees curve in toward the focal point.

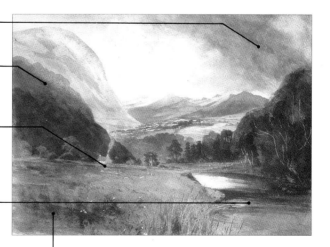

This part of the painting contains less detail and provides a restful area in an otherwise active composition.

◄The arrows show how the composition is arranged to create visual "pathways" leading from the edge of the picture to the focal point.

# *My* landscape looks flat and unconvincing. How can I create the illusion of depth and space *?*

## THE PROBLEM

The greatest challenge in landscape painting is how to achieve an impression of the land and the sky stretching back toward the horizon, so that the viewer can mentally "step right into the picture."

In the painting above the student has used the familiar tricks of linear perspective – overlapping forms and objects of gradually diminishing size – to show that some trees are farther back than others. Yet the picture still looks strangely flat and one-dimensional. Why? Because the student has failed to record the effects of aerial perspective: in other words, the way in which atmospheric haze, consisting of tiny particles of dust and water vapor in the air, causes objects to appear paler, bluer and less distinct the closer they are to the horizon. This is a familiar trap that novice painters often fall into; they "know" that a tree is green, so they paint it green, even though it is way back in the distance and actually appears blue-green or even blue.

## THE SOLUTION

To understand the effects of aerial perspective, it helps to imagine the landscape as having a series of transparent, bluish veils stretched across it every 50 feet or so. The farther back you can see, the more "veils" you have to look through, which is why objects appear bluer in color and hazier in form the closer they are to the horizon.

You can clearly see the effects of aerial perspective in Ronald Jesty's painting *Alpspitze* (opposite). Here the impression of space and depth is quite dramatic, and the whole scene is suffused with a palpable feeling of air and light.

▥ **Spatial planes** There are six distinct spatial planes in Ronald Jesty's landscape: the foreground field, the tree-covered hills, and then the serried ranks of the mountains. You will notice the following changes in the landscape as it progresses from foreground to background.

▥ **Colors** become cooler and less intense the closer they are to the horizon. Compare the bright, warm greens in the foreground to the misty blues of the distant mountains.

▥ **Tonal values** become paler and weaker in the distance, due to the intervening atmosphere. In *Alpspitze* the misty blue peaks in the distance are barely suggested, and this lends a touch of poetry to the picture – a sense of infinity which is always fascinating to the viewer.

▥ **Detail and contrast** are sharpest and clearest in the foreground, becoming hazy and blurred in the distance.

In watercolor, the most effective way to achieve the effects of aerial perspective is to work from background to foreground. Begin with a "whisper," using light values and soft outlines at the horizon, and work up to a "shout" in the foreground, introducing progressively stronger values and colors and greater textural detail.

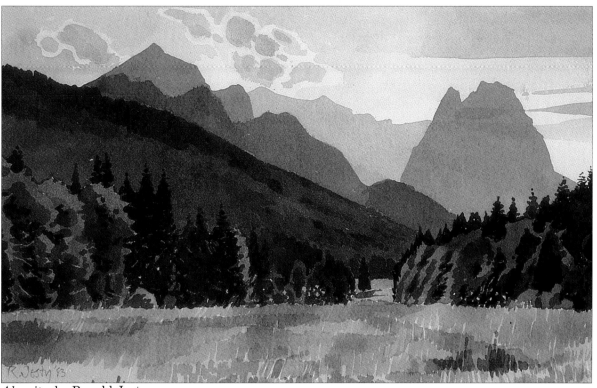

*Alpspitze* by Ronald Jesty

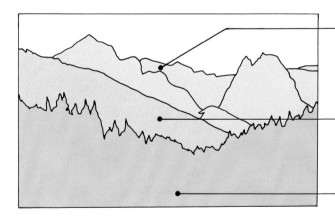

The background colors are
reduced to a cool blue-gray,
leaving values very pale.
Textural detail is lost in a haze.

Middle-ground colors become
cooler and less intense.
Contrasts of texture and value
are less marked.

The foreground colors are warm
and intense, with tonal values at
full strength. Textural details
are clearly defined.

*I can't quite put my finger on why,
but I'm not too happy with
the composition of this picture.*

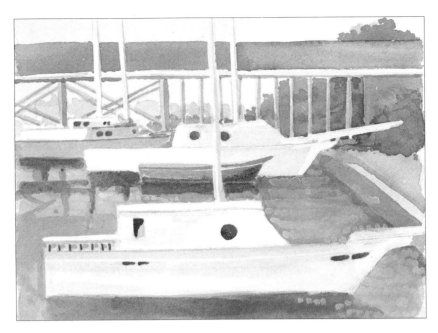

### THE PROBLEM

Our culture favors orderliness in all things. Houses are arranged in straight rows; parks and gardens have neat flower borders and perfectly trimmed hedges; even our food is tidily packaged in cartons and tins.

In art, however, tidiness becomes tedious. Avoid using too many straight lines and repetitive shapes, otherwise your picture will begin to resemble a wallpaper pattern. In the harbor scene above, for example, the boats are too similar in shape and color. Each area of the painting has been neatly filled in with flat strokes of color, so that there is no feeling of the form and texture that make boats such an interesting painting subject.

The composition itself is cluttered, yet it is also boring and predictable due to the over-use of horizontals and verticals. The mast of the foreground boat, in particular, looks awkward because it effectively splices the picture in two.

### THE SOLUTION

In *Day Sailer* (opposite) artist Stan Perrott has chosen to "home in" on one small area of the scene, because this gives him a much more interesting composition. Instead of the serried ranks of rather anonymous boats in the problem painting, here we have a more personalized view of the two little boats tilted up on a mud bank.

**Diversity within unity** The Greek philosopher Plato stated that "composition consists of observing and depicting diversity within unity." In other words, a picture should appear balanced and unified, while containing enough variety to keep the viewer interested and entertained. For example, the repeated use of related objects such as a group of trees creates unity; but, at the same time, diversity is achieved by varying the shape, size and color of the trees, and by varying the distance between them. Correspondingly, the shapes and angles of the solution painting are similar throughout, but none are exactly the same: thus we have diversity within unity.

**Odd numbers** Just as flower arrangers avoid using an even number of blooms in a display, it's best to avoid having an even number of objects in a painting if they are the same size and shape, since this can appear monotonous. If your picture contains, say, two trees, create diversity by making one larger than the other, or a different color, or by pushing one tree farther into the distance. In *Day Sailer* there are two boats – an even number – but one is smaller and darker than the other, and tilts at a different angle, thus avoiding monotony.

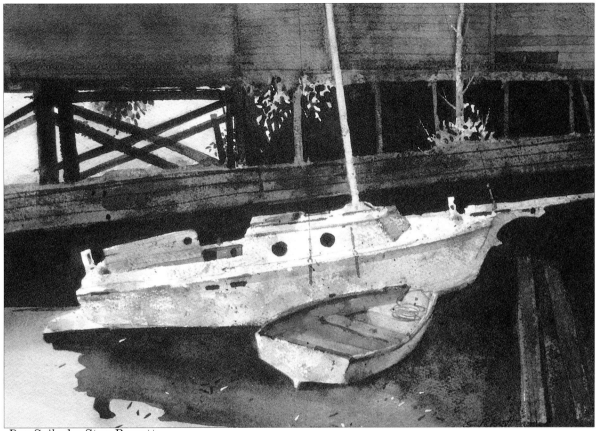

*Day Sailer* by Stan Perrott

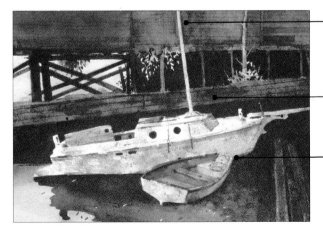

The near-vertical of the boat's mast is echoed by the near-verticals in the background.

The oblique angle of the boat is echoed in the lines of the wooden pier.

The two boats are different in size and color and form an interesting overall shape because they are at angles to each other.

Creative cropping can do much to turn a routine picture into a memorable one. In this painting Stan Perrott moves in close to his subject, cropping off the mast of the boat. This way the subject fills almost all of the picture space, and the viewer is made to feel an intimate part of the scene portrayed.

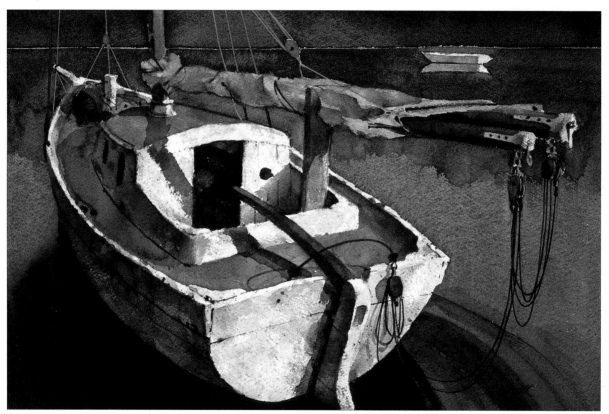

*Love Song* by Stan Perrott

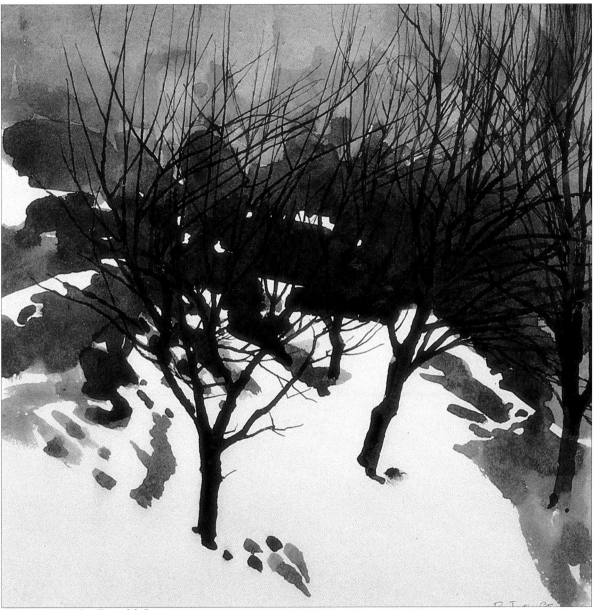

*January 1985* by Ronald Jesty

The use of similar objects or repeated shapes gives unity and cohesion to a picture. Avoid monotony, however, by introducing a hint of variety to the arrangement. In this painting there is a subtle poetry in the way the winter trees are grouped, their arched branches gracefully intertwining.

# *I*'m disappointed with the sky in this painting – it looks weak and uninteresting.

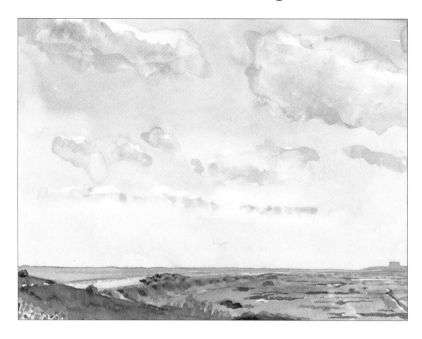

## THE PROBLEM

**F**ailure to paint skies convincingly often results from lack of confidence in handling a subject that is hard to "pin down." Clouds are amorphous things, whose colors and shapes are apt to change even while you're painting them.

The student painting above has its merits: the low horizon line is well placed, giving prominence to the sky, and there is a sense of perspective as the clouds become smaller and flatter as they recede toward the horizon. Overall, though, the picture is weak and tentative. The sky is obviously meant to be the center of interest, but it doesn't contain enough color or drama to draw the viewer's attention. The clouds are floating around in a disjointed fashion, and there is nowhere for the eye to focus.

## THE SOLUTION

**I**n Stan Perrott's painting *Manitoba Skyscape* (opposite) the composition is similar to that of the problem painting, with a low horizon line giving emphasis to the sky. But here the sky is much more dramatic and forceful: the cloud grouping has a unity and cohesion which makes for a stronger, more dramatic image.

Painting skies effectively requires a combination of boldness and good planning.

▪ **Planning** is essential. Know what colors you're going to use at the outset and have them mixed ready so you can work quickly and directly. Having to break off in the middle of a sweeping wash to mix up more paint is likely to prove fatal.

▪ **Boldness** means having the nerve to mix much stronger, richer pigments than you think you'll need. The color may look too strong when it's wet, but you'll be amazed at how much paler it appears when the wash has dried. Also, don't forget that the dark values in the landscape will "knock back" the paler value of the sky even more.

Boldness also means using large brushes, well loaded with paint, and working quickly and loosely so as to inject a sense of movement into the sky. Be spontaneous: there's no point in trying to paint the sky exactly as you see it, since the shapes change so quickly, and if you try to "fix" them you end up with "concrete" clouds.

▪ **Composition** For a landscape painting to be balanced, either the land *or* the sky must dominate. If you choose to emphasize the sky, make sure that it is composed well and contains a strong center of interest. The problem painting looks bland because neither the sky nor the land contains dramatic contrasts of shape or value. In Stan Perrott's painting, on the other hand, the horizontal band of rolling clouds gives strength to the composition and provides an arresting focal point.

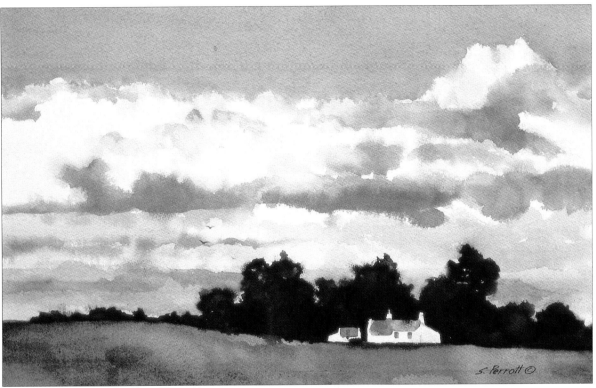

*Manitoba Skyscape* by Stan Perrott

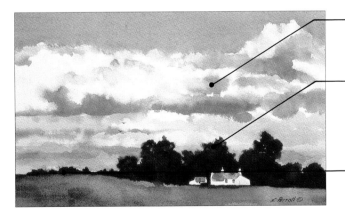

The clouds are grouped and massed to form a strong, coherent shape.

The trees' dark shapes echo and emphasize the cloud forms and provide a link between the blues of the sky and the greens of the landscape.

A low horizon line gives prominence to the sky.

# *How can I make my floral still lifes look more interesting?*

## THE PROBLEM

So you've chosen your painting subject, which happens to be a vase of flowers. Now comes the moment of truth. You are confronted with an object and a sheet of pristine white paper: do you panic and dive straight into the painting, hoping it will turn out alright? Or do you plan your composition calmly and rationally, so as to get the maximum impact out of your subject?

All too often, compositional decisions are made without sufficient thought, and without exploring all the creative possibilities. This applies particularly when the subject is a simple one like a vase of flowers. The inexperienced artist will often plump for the conventional approach and place the subject squarely in the center of the paper, surrounded by a plain background. While there's nothing intrinsically wrong with this set-up, it doesn't always make for an interesting picture because it's too "safe."

## THE SOLUTION

Floral still lifes offer you exciting opportunities for creating dynamic compositions. Don't limit yourself to approaches that are safe and comfortable: experiment with unusual viewpoints; try out different backgrounds; explore the potential of color interactions. It is the uniqueness of your point of view that will make people take notice of your pictures.

Frank Nofer's painting *Rhodies* (opposite) has immediate visual impact. Note, for example, how the pale, delicate colors of the blooms are contrasted against a dark, dark background: a simple, effective device, yet one which many beginners would not think of using. Note also how the artist has included not just one vase of flowers but two, and how they are cleverly linked by the single, fallen bloom lying on the table. Remember, there's no reason why a floral still life has to consist of a single vase of flowers all on its ownsome.

■ **Be flexible** When planning a floral still life, make it a rule never to let your first compositional decision be your last. Try to see beyond mere "things" – a vase of flowers resting on a table, or whatever; look at your subject as a series of shapes, colors and patterns that must link together harmoniously. These shapes, colors and patterns are also the "words" with which you will speak to the viewer, so choose and arrange them carefully.

■ **Using a viewfinder** To help you visualize the different compositional options, examine your set-up through a cardboard viewfinder. First frame the overall composition. Does it look boring? Try moving in closer on one area. You may find that taking a small section from the subject will result in a more interesting composition. Turn the page for more ideas on how to set up exciting floral still lifes.

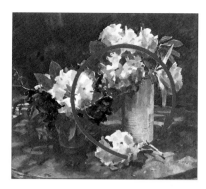

The pale blooms, linked by the flower on the table, draw the eye in a circular "pathway" through the painting.

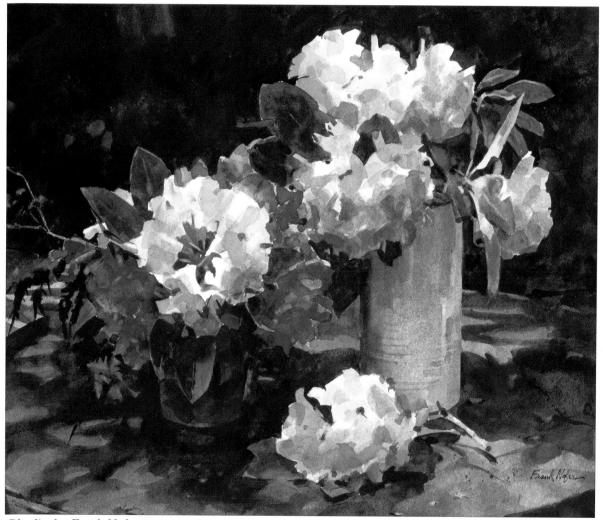

*Rhodies* by Frank Nofer

Wet-in-wet mixtures of ultramarine, burnt sienna and Winsor green are used to create richness and depth of color in the shadows and the dark background.

▶Background objects can introduce contrasting shapes and colors to your floral arrangements. In this painting the contrast is between the pureness and simplicity of the snowdrops and the complex decorative patterns on the jug and on the wallpaper. There's also an interesting juxtaposition between the curving shapes of the flowers and the geometry of the bold diagonal shadow on the wall behind.

▼Using a viewfinder can help you to frame your subject more imaginatively. In this painting, for example, the lilies are cropped off on the bottom and right, creating visual tension. Notice also how the artist has chosen a horizontal format, rather than a vertical one, for these tall flowers. You can almost feel the energy of the flowers thrusting diagonally upward to the top edge of the paper.

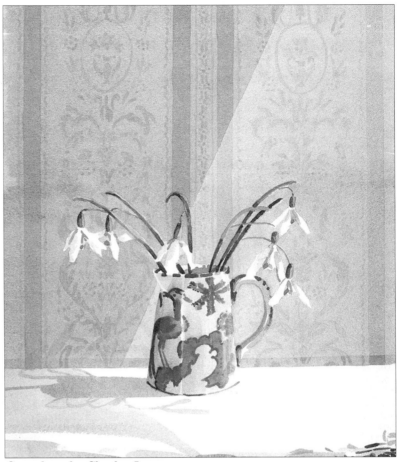

*Snowdrops* by Charles Inge

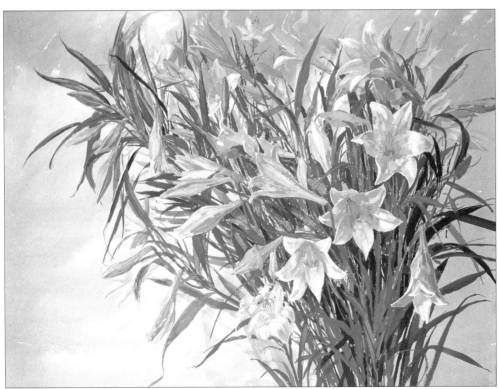

*Lilies* by Pamela Kay

"Less is more" in Chinese painting, and this still life has a perfect simplicity and balance that owes much to the traditions of the Orient. The artist has moved the jug of forsythia away from the center of the paper, thus creating a dynamic visual tension between the subject and the surrounding white space. Yet the expanse of stark white paper also provides an important release, and balances the weight of the jug and flowers. Had the artist placed the subject in the center of the paper much of the energy of the painting would have been lost.

*Jug of Forsythia* by Charles Inge

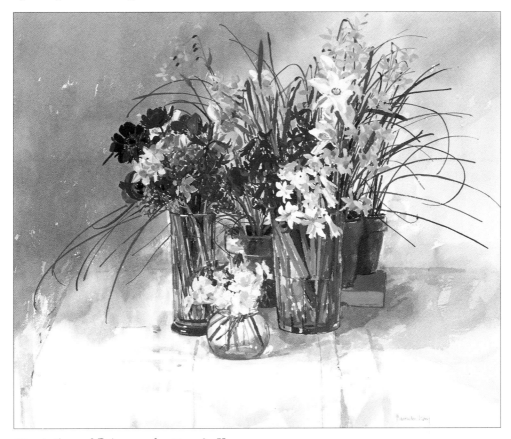

*Hyacinths and Primroses* by Pamela Kay

Too often, still lifes appear static and contrived, so it's refreshing to see a grouping like this one which has an easy naturalness about it. Spring flowers are ideally suited to informal arrangements. Here, the artist has massed together a collection of pots and vases of various size and shape, each filled with a wild tangle of hyacinths, primroses and narcissi that create a riot of color.

# *In this painting the fence looks too obtrusive. How should I have handled it?*

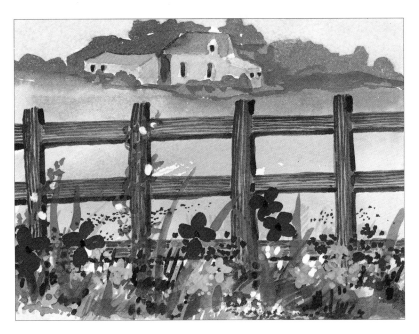

## THE PROBLEM

In any landscape painting the foreground is often the trickiest part to handle. Include too much detail and you discourage the viewer's eye from moving back in the picture plane and exploring the rest of the composition. Put in too little detail, on the other hand, and the foreground becomes an empty, monotonous area.

The main problem with the painting above is the foreground fence. It is painted rather crudely and doesn't contain enough interesting color, texture or light and shade to make it the focal point of the picture. Yet it is clumsy and obtrusive enough to set up a barrier between the viewer and the rest of the composition.

## THE SOLUTION

Foregrounds need to be handled carefully. The trick is to be able to *suggest* detail and texture without overstatement, so that the viewer is aware that there are shadows on the grass, flowers in the field, or whatever, but does not have these details forced upon him or her. In other words, you have to mimic the way in which the human eye perceives things; when we focus on one particular object, the area around that object is seen more or less as a blur because the brain can only take in so much visual information at one time.

In *Farm House at Richmond* (opposite) artist Stan Perrott uses subtle modulations of color, texture and value to create a lively impression of the field in front of the house. These subtle details are pleasing to the eye, but they don't detract from the focal point of the picture, which is the group of farm buildings in the distance.

▪ **Value contrasts** If you have a large expanse of foreground, keep it lively by varying the values and colors. This will encourage the viewer's eye to move around the picture space. In *Farm House at Richmond*, Stan Perrott painted the grass wet-in-wet and lifted off some of the paint with a damp natural sponge and blotting paper to create light areas.

▪ **Textural details** can be suggested with drybrush strokes or by picking out highlights with the blade of a sharp knife. Try spattering dark paint onto a light base wash to suggest stones and weeds, or spatter masking fluid onto a light base wash and then brush in a darker value. Remove the masking fluid, and *voilà!* you have light stones and weeds in a dark area.

▶Light and dark greens keep the eye moving back in the picture plane, toward the focal point.

▶▶Drybrush and spattering techniques indicate weeds and grasses without looking too obtrusive. The white shapes of the daisies are preserved with masking fluid, which is removed when the painting is completed.

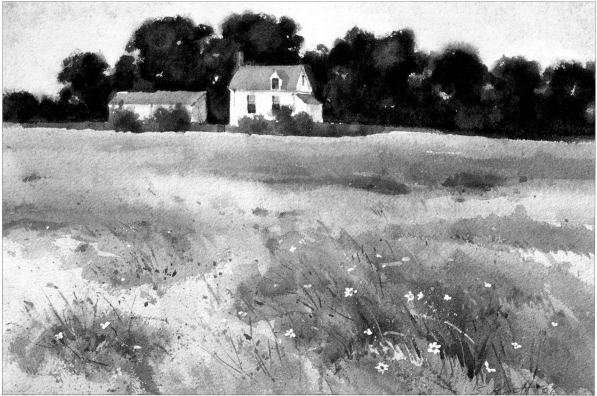

*Farm House at Richmond* by Stan Perrott

**Spattering** Dip a bristle brush or an old toothbrush into the paint, and draw your thumbnail quickly through the bristles to release a shower of fine dots onto the paper. Mask off the rest of the painting with newspaper – paint travels!

**Lifting out** Use a damp brush, a piece of tissue or a natural sponge to lift out pale areas in a dark wash and create tonal variety.

# How can I achieve a better sense of depth in my skies?

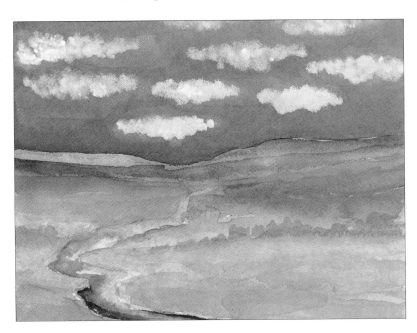

## THE PROBLEM

The laws of perspective apply to the sky just as they do to the land – yet so many perfectly good landscape paintings are ruined by a sky that looks like a limp curtain hanging at the back of the scene. In the painting above, for example, the sky appears curiously vertical. The clouds are too similar in size and shape, and they're too evenly spaced, destroying the illusion of the sky receding into the distance. In addition, the patches of blue sky are too uniform in color and value, without any gradations to indicate atmospheric perspective.

Another mistake here is in placing the horizon line too high up, so that the land competes with the sky for attention. If you want the sky to be the main feature, lower the horizon line so that the land becomes subordinate.

## THE SOLUTION

In contrast to the problem painting, *Somerset Levels* by Lucy Willis (opposite) gives an exciting impression of the vastness of the sky. The way the picture is composed, with a very low horizon line, makes us feel involved in the scene, as if we were actually standing in the field looking up at the heaped clouds advancing toward us. Note also how the clouds overlap each other, creating an interesting diversity of shape and design.

■ **Linear perspective** Clouds appear smaller, flatter and closer together as they recede into the distance, often merging into a haze at the far horizon. Perspective can be heightened even further in your painting by making the nearest clouds much larger, taller and more clearly defined than the others, as Lucy Willis has done in *Somerset Levels*.

■ **Atmospheric perspective** In creating a sense of perspective in the sky, it helps to think of it as a vast dome stretched over the landscape, rather than a mere backdrop to it. Creating this dome-like impression means applying the laws of atmospheric perspective as well as linear perspective.

The sky directly overhead is clearer than at the horizon because we see it through less atmosphere. As we look into the distance, intervening particles of dust and water vapor in the air cast a thin veil over the landscape and sky, making them appear grayer and less distinct.

Reproducing the effects of aerial perspective in your sky paintings will greatly increase the impression of depth and atmosphere. In *Somerset Levels*, the "white" clouds near the horizon are tinged with blue-gray, whereas those in the foreground are brighter and clearer. Accentuate the effect of atmospheric haze by blurring the edges of the farthest clouds wet-in-wet and reserving any crisp edges for those in the foreground.

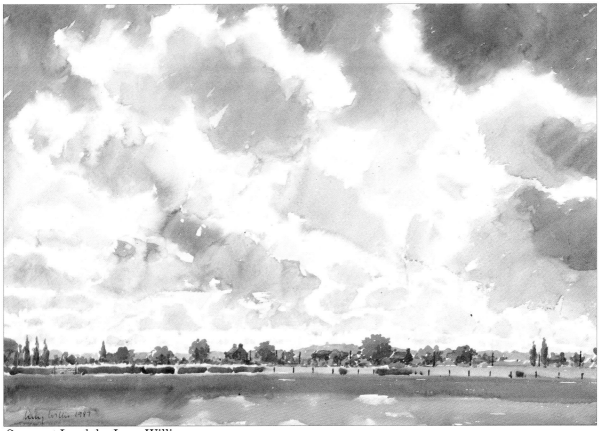

*Somerset Levels* by Lucy Willis

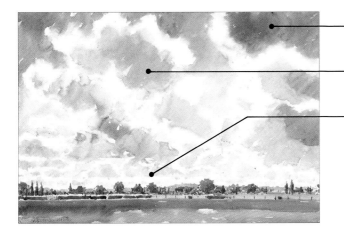

Warm blues bring the foreground sky closer.

Clouds nearest to the viewer are large and strongly colored.

The clouds become smaller, flatter and lighter in value as they near the horizon. The horizon line is low, which places emphasis on the sky and increases the illusion of space.

# *I'm fairly pleased with this street scene, but it seems a little "empty."*

## THE PROBLEM

The vast majority of landscapes contain no figures – and are none the worse for that. But from time to time you'll come across a subject that *does* include people – whether it be a bustling street market or a lone fisherman by a stream. You can't go on forever avoiding such scenes, just because you don't feel confident about your ability to paint people.

Take the example of the street scene above; it might have been painted at five o'clock in the morning, when nobody was up! Without any people to give it life and interest, the street looks a little sad and bleak.

## THE SOLUTION

In *Eymet, France* (opposite) we again have a street scene, but here the artist, Geoff Wood, has filled it with people – and how much livelier it looks!

Figures in a landscape offer many other advantages, too. Their size in relation to their surroundings lends a sense of scale; and they can draw attention to the focal point of the composition, or even become the focal point themselves.

"That's all very well," you might say, "but I can't paint figures." However, for the purposes of a landscape or street scene, a detailed figure study is not what's required. What is important is capturing the attitudes and gestures of the people you're painting. In Geoff Wood's painting the figures are rendered very simply – they're barely more than strokes and dots – yet they convey all the noise and color of a busy shopping street in France.

Carry your sketchbook with you everywhere, and make sketches of people in cafés, sports centers, shops – any place where people gather together and you can sketch them without attracting too much unwelcome attention. Keep the sketches small, and aim to capture the gesture and shape of your subject. Notice how the movement of clothing affects the shape of a figure in action. Pay attention also to the shadow masses – these are important in conveying an impression of the figure's weight and solidity. Even if you only make one or two sketches a day, you'll be surprised at how quickly the natural gestures of the figure become second nature to you.

*Eymet, France* by Geoff Wood

The figures are painted with swift dots and squiggles to give an impression of light and movement.

In this painting we are invited to share in the artist's affectionate memories of his childhood in New Zealand. The figures of the woman hanging out her washing and the old man sitting on the verandah bring the scene vividly to life.

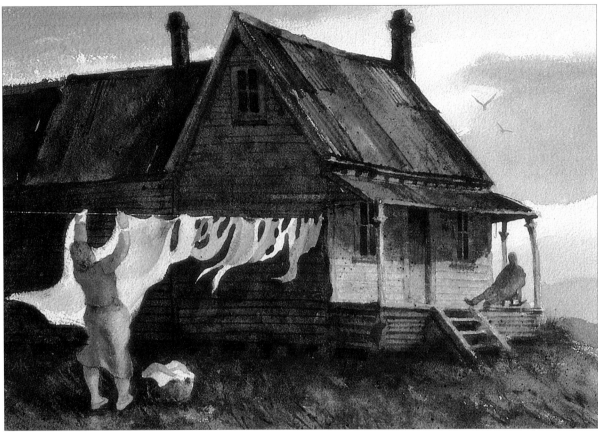

*Monday Morning* by Stan Perrott

**Figure sketches** When you're painting figures in a landscape it isn't necessary – or desirable – to make them highly detailed. As these delightful figure studies by Lucy Willis show, watercolor has a freshness and immediacy that allows you to capture the gestures and personalities of people in a way that's fresh and entertaining.

Follow the artist's example and make watercolor studies of people on the beach, or any other public place of your choosing.

Imagine this lakeside scene without the two tiny figures in the boat. Their size in relation to their surroundings gives a dramatic impression of the sheer scale and grandeur of the natural world.

*Cool and Quiet* by Tony Couch

# *The old rusty fence is the subject of my picture, but somehow it looks "lost."*

## THE PROBLEM

One of the commonest faults in beginners' paintings is that they contain too many irrelevant and distracting details which dilute or even destroy the message of the picture. Take the river scene above, for example – a classic case of trying to say too much and ending up saying very little. The student's reason for painting this particular spot was the intriguing shape formed by the rusty, broken fence leaning out into the water. But he has fallen into the familiar trap of painting everything else in the picture with equal emphasis, so that everything competes for our attention. Instead of being the "star" of the show, the fence becomes just another member of the chorus line.

## THE SOLUTION

One of the golden rules in painting is "Don't give them too much!" Like a dish that contains too many hot spices, a painting which contains a lot of conflicting details will leave the viewer with a jaded palate. Decide what you want your painting to say, accentuate that, and subordinate any conflicting or competing elements.

Compare the problem painting, with its confused jumble of detail and color, to Richard Bolton's ver-

sion of the scene. In *The Rusty Fence* (opposite) the image is more striking because the artist has kept the greatest amount of detail in the foreground and simplified the background. Our attention is now focused on the fence and the foreground trees, which register clearly against the soft shapes and values in the distance.

■ **Selective focusing** You may have seen photographs in which the main subject is in sharp focus, with the background deliberately kept out of focus to give a soft, blurred effect. This contrast between sharp and soft adds textural interest to the picture as well as giving emphasis to the main subject. It's not difficult to see how this effect can be achieved with great success in a watercolor painting. Follow Richard Bolton's example, and use crisp details and strong values in the foreground, or wherever your center of interest happens to be. Then as you move away from the center of interest, begin to use lighter values and blurred, wet-in-wet shapes.

In *The Rusty Fence*, see how the contrast between the sharp-focus foreground and the hazy background helps to create the illusion of depth and space in the landscape. It also lends a touch of poetry to the painting and prevents the objects within it from looking unnaturally hard and brittle.

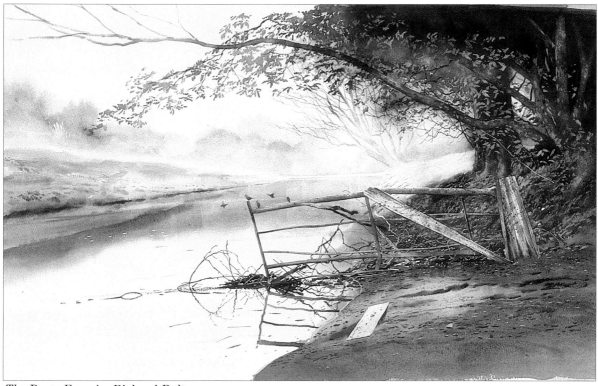

*The Rusty Fence* by Richard Bolton

The trees are painted wet-in-wet to give a pleasing mistiness in the far distance. This also emphasizes the impression of space and depth.

Some middle-ground trees are eliminated to avoid confusion and give emphasis to the foreground trees.

The fence now has a more pleasing shape, and its weathered texture is given greater emphasis. The texture is achieved with a combination of wax resist and drybrush strokes. Details, values and colors are much stronger in the foreground than in the background.

*The Alhambra, Granada, Spain* by Paul Osborne

One of the most attractive qualities about watercolor is its ability to suggest even the most transient effects of light, color and atmosphere found in nature. The appeal of this painting lies in the delicate transition from strong color and detail (sharp focus) in the center of the picture to pale, delicate tints (soft focus) at the edges. This "vignette" effect adds mystery and atmosphere to the scene and plays on the viewer's imagination.

# *T*his still-life group isn't very inspiring. How do I go about creating a stronger image*?*

## THE PROBLEM

When faced with a group of objects for a still-life painting, it's all too easy to choose and arrange them in a way that's haphazard and lacking in thought. The problem is that we tend to choose objects which take our fancy, without stopping to think whether the objects will work together as a group in terms of size, shape, color, and so on. In the still life above, for example, we have a wine bottle (the obligatory wine bottle!), a vase of flowers, a hat and a tea-cloth: two tall, thin shapes and two flat shapes, with nothing to link them together. The student, in common with many beginners, seems averse to the idea of over-lapping objects; everything is standing in line, and so the group looks staid and static.

Another common mistake in the design of a still life is to leave too much space around the group. In this painting the objects are lost in a sea of mono-tonous background.

## THE SOLUTION

It's important to compose a still life so that each individual element contributes to the total design. There is a pleasing harmony and rhythm to the objects in Pamela Kay's still-life painting, *Tureen of Mandarins with Orange Preserves* (opposite). Somehow, everything just "sits right." The group forms a roughly oval shape within the borders of the picture, and everything in the group is organized so as to carry the eye of the viewer on a visual "tour" of

the painting. Another nice touch is that each of the objects in the group shares a common theme: they are all kitchen objects, and all are connected with the process of making preserves.

■ **Unify the subject** When you have a group of objects of different size, shape and color, it is vital that they relate to one another and that the spaces *between* the objects also make interesting shapes. Play around with the arrangement of the objects before starting to paint, and make rough sketches so you can see how the overall shape of the group will look on the paper. Look for points where objects can overlap, because this ties the objects together and creates interesting shape relationships.

■ **Repetition and variation** Try to repeat the shapes and colors within the group, because this sets up visual rhythms which the viewer will respond to. Repeating shapes and forms can also unite and integrate the objects in your still life and prevent them from appearing too scattered. A word of cau-tion, however: beware of making these repetitions too regular, as this can lead to monotony. Introduce subtle variations of size, shape or value to add spice to the design. In Pamela Kay's painting the rounded shapes of the bowls, the oranges and the preserve jar create intriguing visual echoes, yet none is exactly like the other. The same applies with the geometric shapes of the other objects. The colors, too, are nicely tied together, with variations on the blue/orange theme repeated throughout.

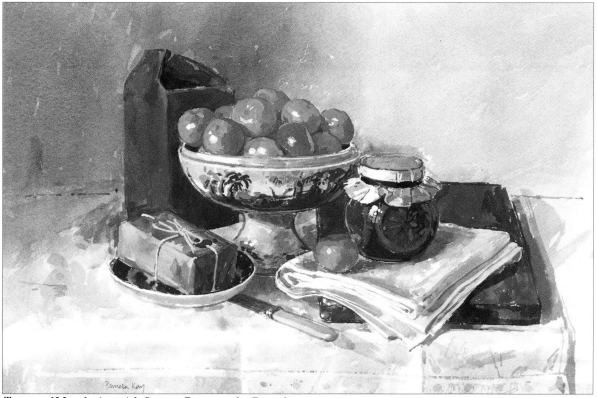

*Tureen of Mandarins with Orange Preserves* by Pamela Kay

Complementary colors – blue and orange – are repeated throughout, creating a lively yet harmonious color scheme.

The repetition of curved and linear shapes gives unity to the group.

The single mandarin pulls the eye down from the fruit bowl, from where it is carried to the left and upward, back to the fruit bowl.

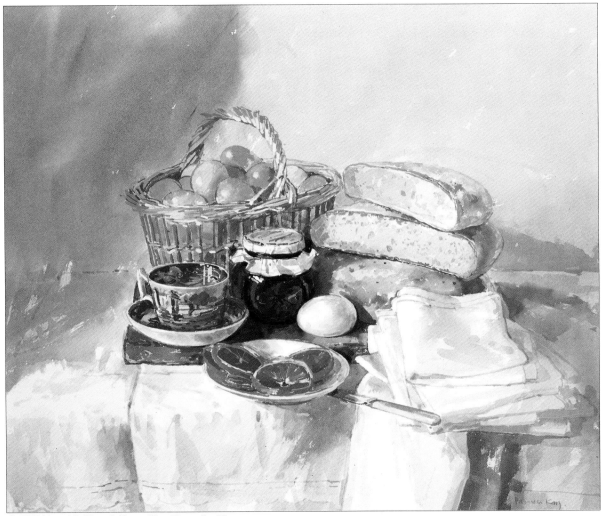

*Still Life with Batch Bread* by Pamela Kay

One way to add interest to a still-life group is through textural contrast. Here the artist plays off the smooth, shiny surface of china and glass against the mat surfaces of the cloths and eggs, and the rugged texture of the batch bread and the straw basket.

A common mistake made when painting a vase of flowers on a table is leaving a wide band of empty space in front of the subject. Placing other objects in this space – perhaps a bowl of fruit or a flower lying on the table – will fill the gap and add interest to the picture. In this floral still life, the line of cherries helps to lead the viewer's eye to the vase of flowers. Note also how the crumpled white cloth adds tonal contrast and stabilizes the vertical format of the picture.

*Sweet Peas and Cherries* by Ronald Jesty

When setting up a still-life group, remember that the shapes between the objects are just as important as the objects themselves and form an integral part of the total design.

This is an intriguing composition because the objects are arranged in a straight row, yet there is nothing monotonous about them. The eye line is placed very low to give full prominence to the positive shapes formed by the jars and bottles and the negative shapes between them. Beautifully controlled, this painting has a quiet timelessness.

*Still Life with Hydrangea* by Ronald Jesty

# *Why does my flower still life look so static and heavy?*

## THE PROBLEM

Compared with other subjects, still life can give you a lot of compositional freedom. You can select whatever objects you like and arrange them to suit your mood. Having so much freedom of choice, however, can make it all too easy to take rash decisions, without considering what the final outcome will be.

Quite obviously a lot of work has gone into the flower still life above, but it suffers because the student has considered the objects first, and the overall design of the picture second. The group appears fixed and immobile because the objects are not linked in a way that encourages the eye to move around the composition and discover exciting things along the way.

The sweet peas, although brightly colored, are not dominant enough, because our eye is distracted by the over-large container. The white plate, being the lightest value in the painting, also catches attention, but because it is placed at the edge of the frame, it leads the eye right out of the picture.

Beginners often forget the importance of "breathing spaces," and this omission contributes to the rather solid, airless feeling of this painting. There are too many hard edges here, and the closely-packed flowers form a dense and solid mass.

## THE SOLUTION

In Richard Akerman's *Floral Arrangements I* (opposite) the set-up is again quite simple, but here the artist uses strong colors and shapes which activate the picture space and make the painting come alive.

■ **Tension and release** Our lives are centered around periods of activity and rest. In the same way, a painting should contain active and restful passages, or tension and release. The objects in the problem painting appear fixed because they are overstated; there are no quiet, underplayed areas to provide a welcome "breathing space." Compare this to Richard Akerman's painting, in which the active shapes of the flowers and foliage are balanced by the quiet, simple shapes around them.

■ **Leading the eye** When you're planning a composition, it's important to make sure that the lines, shapes, values and colors are arranged so as to lead the eye through the painting. See how Richard Akerman creates a subtle diagonal, formed by the topmost daffodil and the bottom leaf at right, which leads to the small ceramic pot beneath. Here our eye is caught by the white daisies to the left, which press upward toward the daffodils. This circular movement generates a sense of life and movement and makes us feel actively involved in the picture.

*Floral Arrangements I* by Richard Akerman

In this painting, the objects are arranged to set up subtle lines and rhythms which direct the eye from one area to another. The diagonals in the background provide a strong stabilizing note, counterbalancing the energetic shapes of the flowers.

You can create inherent movement in a painting by varying the speed, flow and direction of your brushstrokes. In this picture there is an interesting counterpoint between fast, active lines and slow, passive ones. The converging lines of the terraced slope "zoom" us into the middle distance, where the pace suddenly changes and becomes more leisurely. The two trees on the right are vital to the composition: they prevent the eye from moving out of the picture, and also act as a "hinge" between the horizontals in the background and the diagonals in the foreground.

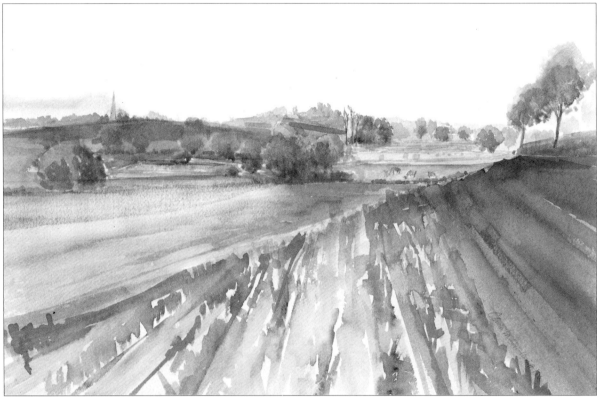

*North Slope* by Clarice Collings

*Afternoon Tea* by Clarice Collings

Beginners often fall into the trap of painting hard, stilted outlines around objects, thus breaking up the continuity of the picture. As this still life shows, soft edges and melting color diffusions are not only more poetic, they also encourage the eye to move around the picture. Some of the shapes here are barely discernible, yet they "read" as cakes and cookies and plates and jugs. Remember, in watercolor, brevity is all.

# *My landscapes looks rather stilted and wooden. Where am I going wrong?*

## THE PROBLEM

The difference between a photograph and a painting is that a painting expresses more than just the surface appearance of things. With each stroke of the brush, the artist expresses his or her own personality and feelings about the subject. This applies particularly in a watercolor painting, in which every brushmark remains visible and therefore becomes an integral part of the finished image.

Beginners, though, have a tendency to be rigid and inflexible in their brushwork because they lack the confidence to be able to let go and adapt to the spontaneous qualities of watercolor. Take the landscape painting above, for example. Rather than using his brushstrokes to interpret the movement of the trees swaying in the wind and the water rushing over the rocks, the student has "played safe" and tried to make a slavish copy of the subject. Instead of flowing together naturally, each element in the scene is "compartmentalized" within a rigid outline. Overcautious brushwork renders the painting rather flat and characterless.

## THE SOLUTION

Don't be a slave to your subject – break loose from it and let your enjoyment of it come through in your painting.

When we look at *Environs of Pamajera # 39* (opposite) the word that springs immediately to mind is "exuberance." The artist, Alex McKibbin, reacts not merely to the outward appearance of trees, rocks and water but to the pulse and energy they contain. Every inch of the painting is alive and vibrant. With his sweeping, fluid brushstrokes, McKibbin makes us *feel* the energy of the wind in the trees and the water rushing over the rocks. The problem painting is rigid and stiff, like a puppet; *Environs of Pamajera* is as supple as a dancer.

To get more expressive power into your paintings, it's vital to put more energy into your brushstrokes. Remember those movement classes at school, when you had to pretend to be a tree swaying in the wind, or a wave crashing on the shore? Embarrassed giggles all around. But you have to get into a similar frame of mind when you're painting: a tree grows upward and outward as it reaches for the light, so follow that movement with your brush, sweeping upward from the base of the trunk. Clouds billow and puff; water gently quivers; rocks tumble haphazardly toward the shore. If you can capture the inherent dynamics of nature with your brushstrokes, your paintings will have more life, more energy, more emotional impact.

Achieving this energy and spontaneity, without losing control of the medium, requires skill, and this can be gained only through practice. Follow the example of Alex McKibbin, who likes to paint the same subject many times, so as to become really familiar with it. The more he paints, the more he gets the feel of the subject and the freer and looser his brushstrokes become. Learning to paint is a bit like learning to drive a car. The ride may be a bit bumpy

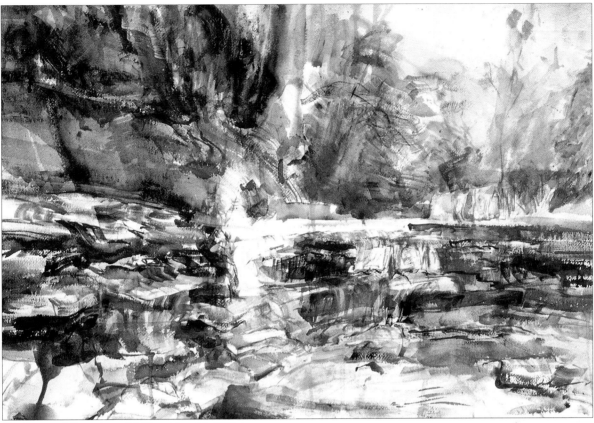

*Environs of Pamajera #39* by Alex McKibbin

Energetic brushstrokes convey movement in the trees.

Downward sweeping strokes lead the eye to the waterfall.

Transparent glazes of violet, blue, yellow and green are used throughout, helping to tie the whole painting together through color harmony.

Loose drybrush strokes allow the picture to "fade out" at the edges, concentrating our attention on the waterfall – the focal point.

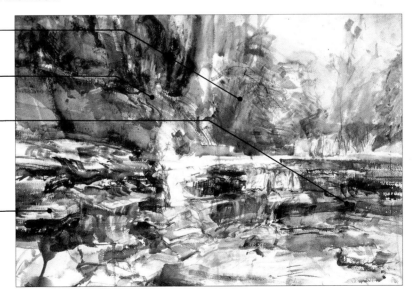

and jolting at first, but the more you do it, the smoother it becomes.

Remember, you don't have to paint a masterpiece *every* time: sometimes it's good simply to experiment and discover new ways of manipulating the brush and the paint. On the next page you'll find some more examples of expressive brushwork. Why not use these as a jumping-off point for your own ideas? Along with the following suggestions, they'll help you to get more out of your paintings – and put more into them.

▩ **Loosen up** Expressive brushstrokes can be achieved only if your hand and arm are relaxed. Hold the brush loosely, not too close to the ferrule, and apply the paint to the paper lightly but confidently. To help you loosen up, it may be helpful to work on a larger size paper than you normally use, and with bigger brushes, which encourage a more expansive approach.

▩ **Line speed** Try to convey the movement and energy inherent in living forms by varying the speed, thrust and direction of your brushstrokes. The interaction of fingers, wrist and arm is important here. Use your whole arm to make fast, sweeping strokes which capture the turbulence of a stormy sky; for fine, precise details, rest the heel of your hand on the paper, and use only your fingers and wrist. Remember, the way you manipulate brush, water and paint can have a marked effect on the emotional quality of the finished work.

▩ **Lost and found edges** By varying the pressure on the brush, you can make lines that vary from thick to thin in a single stroke. You can even "lose" lines and "find" them again, creating broken contours which lend rhythm to the work and allow it to "breathe." Broken contours also break down the barriers between one form and another, allowing them to link together harmoniously; one common mistake made by beginners is to put rigid lines around everything so that the painting looks a bit like a jigsaw.

**Horizontal** Restful, calm

**Diagonal** Spontaneous, dramatic

**Random** Energetic

**Undulating** Tranquil, gentle

**Expressive lines** Be aware of the emotional impact of the lines and strokes in your painting and try to choose those which are compatible with the mood you want to capture. To help you "limber up" before starting a painting, make random brushstrokes like these ones and consider what emotions they convey.

*Roses* by Clarice Collings

*Rough Sea at Hastings* by Leslie Worth

▲Be spontaneous! Watercolor is the ideal medium for portraying the magnificent shapes and colors of flowers. Here the artist works without the "safety net" of a pencil outline, capturing the shape of each leaf and petal with just one or two strokes and lifting out the wet color here and there to create tonal variety. This spontaneous approach gives an impression of life and movement.

◄With watercolor you can create subtle diffusions of color that capture intangible effects such as mist, rain and sea spray. For this painting the artist began by flooding in his colors wet-in-wet. Then he worked vigorously over the paper, scrubbing and lifting and scumbling the paint so as to create a swirling, vortex-like movement. Notice how the brushstrokes lead in from the corners of the painting and direct our eye to the figures on the shore.

# *P*roblem *S*ubjects

*E*very painter is confounded by certain subjects that seem to cause particular difficulty. When painting skies, for instance, we encounter most of the technical problems associated with controlling large areas of wet paint. Flowers are another popular painting subject, yet capturing their delicate forms and subtle colors is no easy matter.

Many of the problems encountered, however, stem from the same source: the student tries too hard to make a photographic copy of the subject, and ends up with a dull, routine picture. This chapter shows you how to harness the expressive potential of watercolor to suggest textures and forms without overstating them.

As Henri Matisse once put it: "I would like to paint as a bird sings: simply, naturally, unaffectedly." These are precisely the qualities that a good watercolor painting should possess.

*Poppies and Gourd* by Ronald Jesty

# *H*ow do you portray a bright, sunny day*?*
## My picture has turned out much duller than I intended.

## THE PROBLEM

**W**hen painting a scene bathed in bright sunshine, many beginners underestimate the often very strong contrasts of light and shadow that occur. Working outdoors, one is easily "blinded" by the bright sunlight, which makes it difficult to judge colors and values accurately. A painting that seemed vibrant and colorful at the time it was painted often looks disappointingly flat when examined again later.

The composition of the painting above is basically very good, with the building on the left forming a "frame" for the scene beyond. The only problem is the overall lack of contrast between the warm, sunlit areas and the cool shadow areas. The trees on the right, for example, are an uncertain mass of muddy greens, with no feeling of light filtering through the foliage. Had the student thrown a deep, luminous shadow across the foreground and accentuated the lights and darks in the middle ground, the picture would have been much more exciting and vibrant.

## THE SOLUTION

**W**hen composing a sunny scene, remember that *either* the bright, warm areas should dominate, *or*

the cool, dark shadow areas. If there is an even spread of lights and darks, the effect of bright sunshine will be lost. The problem painting, for example, lacks atmosphere because the colors are too similar in value and intensity. Compare this to *Dappled Garden Path* by Lucy Willis (opposite), in which dark values predominate yet the overall impression is one of sparkling sunshine.

■ **Shadows** It may sound like a contradiction, but shadows play an important role in conveying an impression of bright sunlight. In *Dappled Garden Path* the foreground trees are mostly in shadow, and we glimpse a small, sunlit patch of the garden behind them. Because it is surrounded by dark greens, this warm, bright area appears the more intense, and our eye is automatically drawn to it; thus it forms the focal point of the picture.

■ **Warm and cool** Everything the sun hits becomes warmer and more intense in color, whereas objects in shadow are correspondingly cool. Adjacent warm and cool colors have the effect of intensifying each other, and this creates a luminous glow that spells sunshine. Remember this when mixing your colors. Don't just think "green"; think, "Is that a warm green

*Dappled Garden Path* by Lucy Willis

Dark values make the sunlit areas sparkle through contrast.

Transparent colors glazed dark over light appear clean and fresh.

Blue-violet shadows reflect a lot of light.

*Tossa de Mar* by Geoff Wood

◀The joy of watercolor painting is that the white of the paper can play such an expressive part. Here it is used to capture the glare of the Mediterranean sunshine in a Spanish street. Notice how the shadow of the foreground building creates a "frame" for the scene beyond.

▼Shadows are a marvelous device for conveying an impression of bright sunshine. Here the pattern of shadows cast by the trees activates the composition and creates a buoyant, spring-like feel.

*Spring Sunshine* by Lucy Willis

or a cool green?" Examine Lucy Willis's painting, and see how she weaves a pattern of warm and cool color throughout the composition.

■ **Shadow colors** On a sunny day there's a lot of ultraviolet light around, and blue-violet light rays are often reflected in the shadows. If you really look hard at the branches of a tree, for example, you may be surprised to see that they have a reddish-mauve tinge. Notice how Lucy Willis has painted the old wooden shed a cool blue-brown; far from looking strange, it somehow communicates the intensity of the light falling on the garden.

■ **Brushwork** The white, light-reflecting surface of watercolor paper is a distinct bonus when painting sunny scenes. Yet many amateur painters seem suspicious of the idea of leaving areas of the paper untouched. They smother the paper in thick, opaque layers of paint and then wonder why the picture looks gloomy. In contrast, study *Dappled Garden Path*, and see how the artist builds up thin glazes of transparent color, wet over dry, so that the light is allowed to bounce off the paper and up through the colors. Note also how tiny slivers of white paper are sprinkled throughout the picture, creating the effect of light sparkling on the leaves as they rustle gently in the summer breeze.

*I am disappointed with this portrait.
The sitter looks more
like a doll than a human being!*

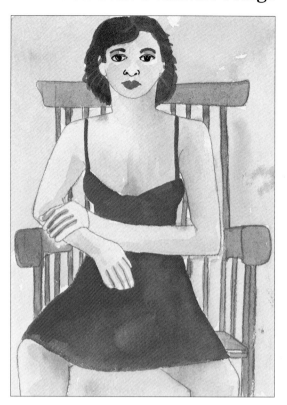

### THE PROBLEM

Figure painting in watercolor has a reputation for being difficult, if not downright impossible. But, as so often happens in watercolor, the biggest difficulties usually arise from the artist's lack of confidence and an unwillingness to let go and allow the medium its fullest expression.

The portrait above is a case in point. The student's lack of confidence is betrayed by the stiff and awkward rendering of the figure, with its rigid pose and tightly drawn outlines. It is an understandable mistake to "dry up" when faced with a difficult subject; but it's a mistake that's death to any watercolor.

### THE SOLUTION

Learn to enjoy the fluid and mercurial qualities of watercolor – qualities that make it ideal for depicting the subtle lines and curves of the human form and the play of light upon its surfaces. The best watercolor portraits are not "posed" at all but are painted on the spur of the moment, perhaps when the subject happens to be relaxing in an armchair or strolling in the garden. *9.30 am* by Joan Heston (opposite) is a delightful example of a relaxed and informal portrait, with none of the stiffness that can result when a sitter is forced into holding a static

and unnatural pose for a long period of time.

■ **No boundaries** One habit that should be dropped like a hot potato is that of drawing a rigid outline of the figure and filling it in with color. This kills any feeling of life and movement in the figure and effectively cuts it off from the background so that it looks like a cardboard cut-out. By all means make a few light pencil marks to plot the position of the figure, but don't treat them as boundary lines that can't be crossed; nothing should be allowed to inhibit the speed and flow of your washes.

Notice in *9.30 am* how the outlines of the figure are mainly soft-edged and blend naturally into the surrounding space. This gives an impression of a living, breathing person: we feel that the woman could get up out of her chair at any moment.

■ **Keep it fluid** If you work in a dry and sparing manner, with timid brushstrokes and a brush that is starved of paint, it's not surprising if the finished result looks lifeless. Always use as large a brush as you dare, to discourage fiddly strokes, and load it with plenty of pigment. It's a good idea to work on damp paper; this makes it easier to lift out color for highlights, or to wipe out mistakes. It also means that your colors can flood into each other wet-into-wet, creating subtle, translucent skin tones.

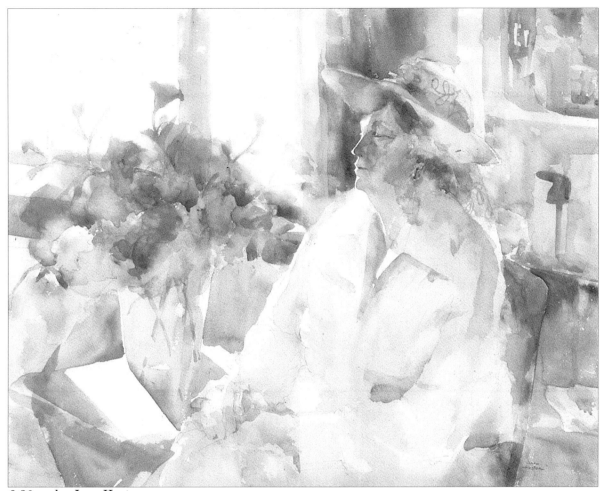

*9.30 am* by Joan Heston

The crisp edge of bare paper suggests strong sunlight lighting up the edge of the face. Bold, overlaid washes in the face add a lively touch.

"Lost" edges help to unite the subject with the surrounding space.

# *H*ow do you capture the delicacy and fragility of flowers*?* My painting looks heavy and leaden.

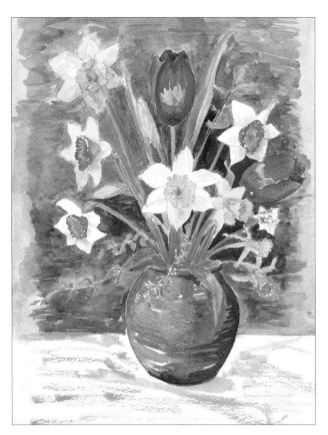

### THE PROBLEM

Most of us have experienced the frustration of setting out to capture the elusive beauty of flowers, only to be disappointed with our ham-fisted attempts! Flowers are so attractive, it's hard to resist the urge to paint them in every detail – and this is where the problems start. As the still life above demonstrates, beginners often fall into the familiar trap of trying to create a photographic impression of the flowers, which inevitably leads to an overworked image. In this example, the flowers look hard and brittle instead of soft and delicate, and the colors are muddy instead of bright and fresh.

Another fault in this painting is in the arrangement of the flowers, which is too formal and contrived: the blooms look as if they are standing to attention. Also, the two red tulips add a discordant color note – as does the rather gloomy background, which gives the painting a claustrophobic feel.

### THE SOLUTION

Painting flowers well requires close observation to detail and constant practice. However, the most essential thing is knowing how to interpret creat-ively the particular *character* of the flowers you have chosen to paint – whether they be huge exotic lilies or tiny, dainty snowdrops.

■ **Setting up** Try to keep the arrangement of your flowers simple and informal. Stylized or symmetrical groupings tend to look stiff and unnatural in a painting. Arrange the blooms so that they overlap each other, and include profile and back views of some of them. This adds variety of shape as well as accentuating the three-dimensional impression. In Lucy Willis's painting *Narcissi in Sunlight* (opposite) the flowers are not "arranged" but allowed to fan out naturally and gracefully, just as they would when growing out of the earth.

A vase full of multicolored flowers is not always a good idea, because the colors fight each other and destroy any impression of delicacy. It's far better to choose flowers of the same color, or a harmonious arrangement of closely related colors.

■ **Mixing colors** Freshness and clarity of color are essential in flower painting, so be sure that you are familiar with your pigments and how they mix together. Flowers may be colorful, but you don't need a vast array of pigments in order to paint them. In

▶ Flower forms are built up from light to dark with glazes of warm and cool color. Areas of white paper provide "breathing spaces." Flowers viewed from the back can be just as interesting as those viewed from the front.

▶ Spontaneous brushstrokes and lost and found edges give a sense of natural, living forms.

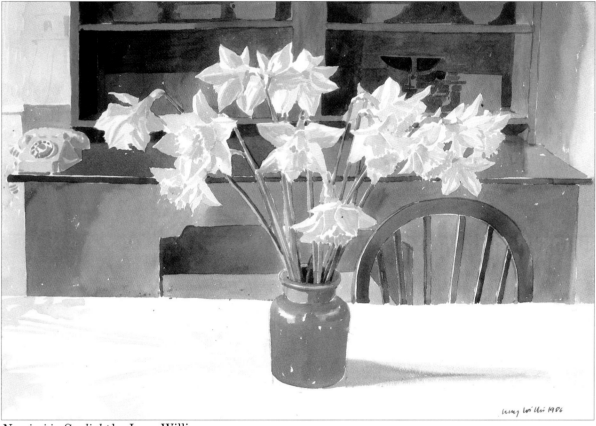

*Narcissi in Sunlight* by Lucy Willis

◀ Cast shadows add design interest and help to anchor the vase of flowers to the table top.

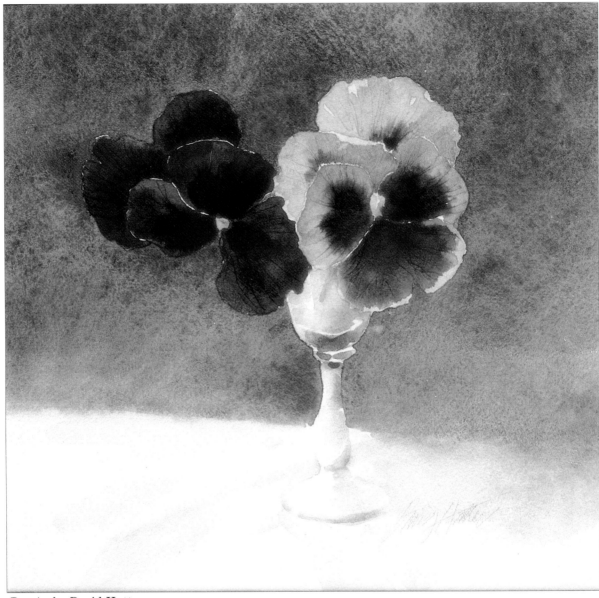

*Pansies* by David Hutter

fact, a simple palette often produces the best results, because it is likely to be more harmonious. When choosing your colors, avoid the more opaque ones such as yellow ocher in favor of the really transparent ones like alizarin crimson, lemon yellow and rose doré. When mixing colors, don't use more than two or three pigments; otherwise the color will turn muddy and opaque. For maximum vibrancy, build up the forms of petals and leaves with thin glazes of warm and cool color which allow light to reflect off the paper.

■ **Lost and found edges** When rendered too tightly and carefully, flowers tend to look as though they have been petrified. In the problem painting the

student has made careful outline drawings of each flower and then blocked them in with color, almost like painting-by-numbers, with the result that they look static. Flowers are natural, living things, and should be painted as such. Hold your brush lightly to encourage fluid brushstrokes, and don't try to control the paint too much. Introduce a variety of crisp "found" edges and soft "lost" ones; this gives life and movement to the flowers and also helps to create an impression of three dimensions. For example, reserve most "found" edges for the foreground flowers to give them emphasis, while "losing" the edges of some flowers at the back and sides of the arrangement.

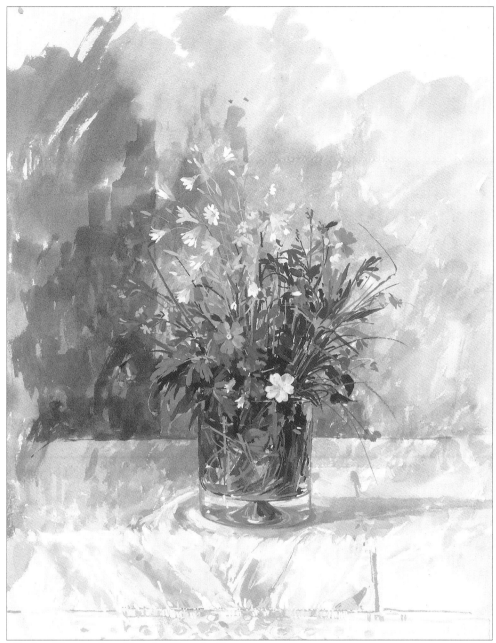

*Spring Flowers in a Glass* by Pamela Kay

◄ To capture the velvety texture of these wine-dark pansies, the artist wetted the flower shapes with clear water and dropped his colors in when the paper had almost dried, allowing them to spread and mingle softly together.

▲ Flowers that grow in the wild have a simple charm which is perfectly captured in this delightful study. Note the harmony of mauve-pink-gray used throughout, with the single yellow flower providing a focal point. Compare the light, airy quality of the background washes to the heaviness of the problem painting.

# *H*ow do you handle reflections in water*?*
## They're lovely to look at,
## but a devil to paint*!*

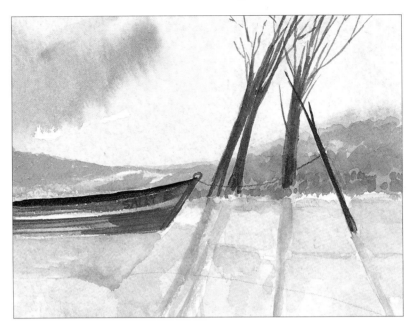

## THE PROBLEM

**W**ater is one of the most popular painting subjects, yet it isn't an easy one to get right. Reflections, in particular, can be confusing and are often not well understood. Painting reflections in water takes practice and close observation; novice painters usually go astray because, first, they don't understand the way reflections behave and, second, they are too timid in their approach.

In the painting above, the reflections don't ring true because the student hasn't observed them properly. Notice, for example, how the reflections of the angled trees and the boat extend in the same direction; in reality they would lean in the opposite direction, to form a mirror image.

Even the calmest water is often disturbed by ripples and currents which break up and distort reflections, thus creating lovely wavering patterns. But in this painting the reflections are not at all exciting in design; in fact they don't really look like reflections at all! In addition, they are much too pale and wishy-washy, presumably because the artist has assumed that if the water is light in color, reflections, too, must be light.

## THE SOLUTION

*F*ishermen Repairing Nets, Caorle by Ronald Jesty (opposite) is a perfect example of how reflections *should* be painted. Here, simplicity is the keynote: the reflections of the fisherman and his boat are rendered with dark, limpid washes which give a lifelike impression of the smooth, gently undulating surface of the water.

■ **Techniques** Fluid and transparent, watercolor is tailor-made for painting reflections in water. There are a number of techniques you can use, depending on the effect you want to convey. In this painting, Ronald Jesty emphasizes the smooth glassiness of the water through the use of strong contrasts of light and dark value. Transparent washes and glazes are applied one on top of the other to build up a depth of value and color in the reflections. (Note how strong and well defined they are, compared to the rather feeble reflections in the problem painting.)

In a different approach, Cathy Johnson creates softer, more muted reflections in *Still Pool* (page 105). This she achieves by flooding her chosen colors onto damp paper and then allowing them to fuse together wet-in-wet.

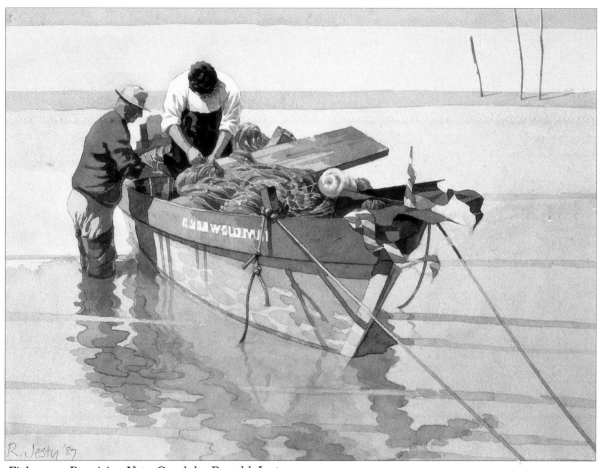

*Fishermen Repairing Nets, Caorle* by Ronald Jesty

Expressive "squiggles" indicate the water's undulating surface.

Reflection curves away from the figure.

**Observing reflections** Before
you start to paint, take the time
to look at water reflections and
observe the points made below.

In still water, reflections appear
almost as an exact mirror
image.

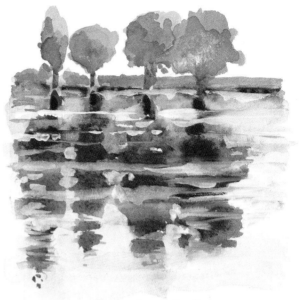

In moving water, reflections
break up and appear longer
than the objects they reflect.

An object in the water that
leans away from you will appear
to have a shorter reflection, but
an object leaning toward you
will have a longer reflection.

Reflections of dark objects
usually appear slightly lighter in
value; reflections of light objects
appear slightly darker.

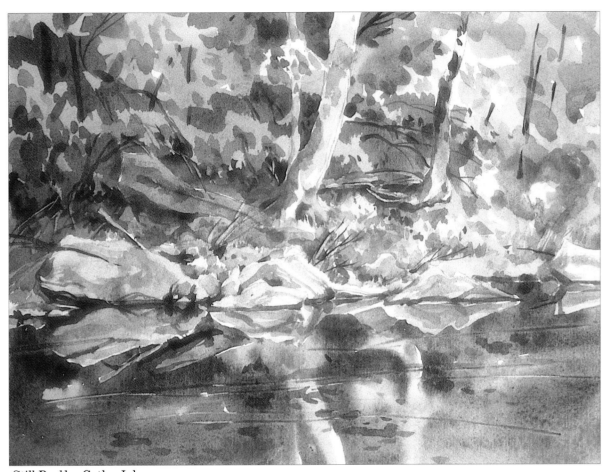

*Still Pool* by Cathy Johnson

In this painting, colors were flooded onto damp paper to create an impression of perfectly still, brackish water reflecting the green of the forest. Soft, pale reflections were lifted out of the damp wash with a clean brush, and the smooth ripples were scratched out of the wash with a sharp blade just before it dried.

# *My* clouds always look like cotton candy. How can I make them look more realistic ?

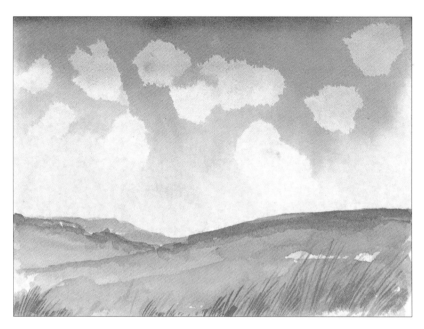

## THE PROBLEM

When painting clouds, the chief fault is nearly always timidity, while overworking runs a close second. Timidity results in little, shapeless, "cotton candy" clouds, usually created by dabbing gingerly at the wet sky wash with a piece of tissue to lift out pale shapes – as is the case in the painting above. It needs to be emphasized that clouds actually have form; they're not just reversed-out shapes. On the other hand, pushing the paint around and generally overworking the colors tends to result in clouds that look as heavy as lumps of concrete.

## THE SOLUTION

The colors and shapes of clouds can change very quickly, and this often causes the novice painter to panic and make a mess of things. The solution lies in learning to harness the light, fluid qualities of watercolor and working quickly and spontaneously to capture a fleeting impression of clouds instead of trying to create a photographic copy.

In *Mountain Retreat* by Moira Clinch (opposite) the clouds are painted very simply, yet they have three-dimensional form as well as radiating light and luminosity.

■ **Keep it fresh** Resist the temptation to push the paint around too much when you're painting clouds, for this quickly destroys the freshness and transluc-

ence that is so vital in a sky painting. Decide which colors you want to use *before* you start painting – don't muddle them around on the paper trying to get them "just right." To retain maximum transparency, keep your color mixes simple: why mix three pigments when one or two will do the job far better?

■ **Good timing** Apply your colors with as few brushstrokes as possible. The more you push and prod, the less cloud-like your clouds will become. If you do need to modify an area, remember that correct timing is vital. If you apply a second wash while the first is still wet, or when it has dried too much, there's a danger of unsightly streaks and marks. The second the shine begins to go off the first wash is generally the optimum time to add a second wash.

■ **Three dimensions** Most clouds, particularly heaped cumulus clouds, are three-dimensional and have distinct planes of light and shadow. In *Mountain Retreat* Moira Clinch uses a variety of warm and cool grays to model the shadowed parts of the clouds, leaving small areas of bare white paper to stand for the sunlit highlights.

Pay attention to the edges of the clouds, too. Clouds are predominantly soft-edged, although cumulus clouds also have some hard edges, particularly where the lightest part of the cloud is outlined against a deep blue sky.

▶ Cloud shadows are modeled with warm and cool grays built up from light to dark. Slivers of bare paper create bright highlights in backlit clouds.

▶▶ A variety of hard and soft edges gives form to the clouds. Color is scumbled and lifted out to give movement and a vaporous effect.

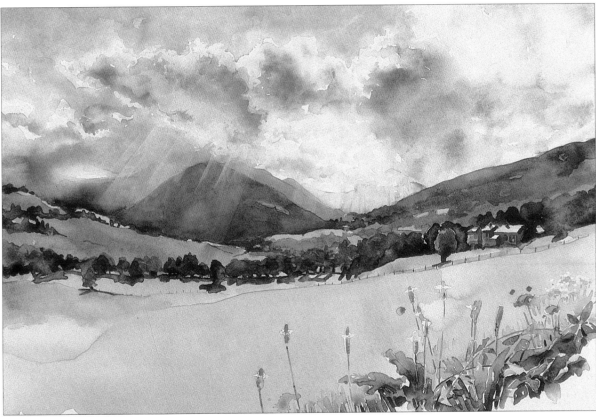

*Mountain Retreat* by Moira Clinch

◀ Here the artist uses a clean, damp brush to make scumbled strokes at the edges of the clouds to give a soft, vaporous effect.

# *T*he building in my painting looks flat, like a cardboard cut-out. How can I make it look more solid and real*?*

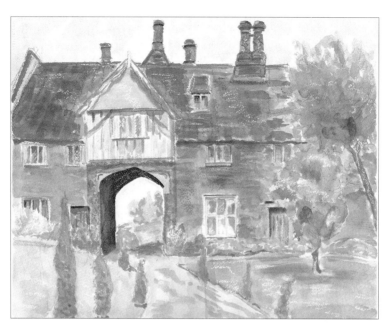

## THE PROBLEM

**A** lot of beginners tend to shy away from painting buildings because they think an intricate knowledge of the rules of perspective is required. In the painting above, the student has cunningly avoided the problems of complicated perspective by painting the house from a straightforward viewpoint. The effect, however, is flat and one-dimensional, rather like a piece of stage scenery.

The subject appears to have been painted on a dull, overcast day: there are few contrasts of light and shade to emphasize form and bring out the interesting features and surface textures of this lovely old building. Note also the absence of a cast shadow to indicate that the archway and the portion of the upper story immediately above it project beyond the rest of the building. (By the same token, the shadow under the archway looks odd because it is the only really dark value in the painting – it doesn't connect with anything.)

Another point to note is that the ends of the building are out of the picture, and this adds to the cardboard cut-out effect. The image would have been much stronger and more effective had the student moved the house farther back and set it against a contrasting background.

## THE SOLUTION

**I**n *Delta Farm* by Stan Perrott (opposite) the building is not so grand as that in the problem painting, yet it looks far more solid and real.

▨ **Lighting** The form of an object is revealed by the contrast of light and shade on its surface, so shadows and cast shadows are a powerful element in making buildings look three-dimensional. Generally, late afternoon is a good time to paint buildings, when long shadows travel across the contours of walls and throw surface features into sharp relief. If possible, position yourself so that the sun is at a three-quarter angle to the building, because this is the most revealing of form.

In *Delta Farm*, note how the jutting gable on the farmhouse casts a strong diagonal shadow behind it. Without this shadow we would not know that this part of the building extends forward.

▨ **Lost and found edges** Beginners often make the mistake of putting a hard outline around a building, which effectively cuts it off from its surroundings. In contrast, note how Stan Perrott emphasizes light-struck areas with hard edges, while "losing" some edges in the shadows. This emphasizes the advancing and receding planes of the building and renders it more sympathetic to its surroundings.

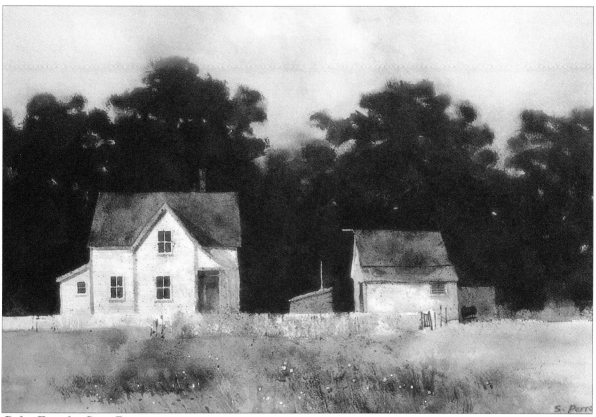

*Delta Farm* by Stan Perrott

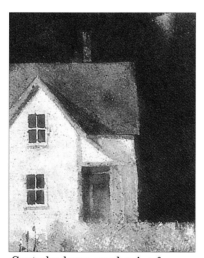

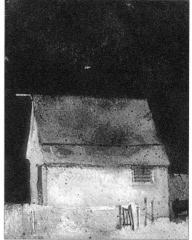

Strong value contrasts between the building and background make for a more powerful image. Hard edges give crispness and definition in the light-struck areas.

Cast shadows emphasize forms.

Lost edges give a sense of atmosphere. Subtle gradations of color prevent large areas from looking flat and monotonous.

# *I* always end up in a mess when painting foliage, there's so much detail to cope with*!*

## THE PROBLEM

**W**hen it comes to painting trees and foliage, there are two faults that occur time after time. One is lack of observation and the other is muddled brushwork. The problem is that, even when faced with such a complex mass of foliage as in the scene above, the beginner tries too hard to render every leaf and twig in order to make the trees look "real." Such a task is, of course, overwhelming, and fatigue inevitably sets in. The student stops looking at the subject, and relies instead on received notions of what a tree is *supposed* to look like. At this point, colors begin to turn muddy, brushwork becomes sloppy, and the result is a stereotyped mass of "lollipop" trees.

The main fault with the painting above is that there is little sense of light and shade, and no sense of movement in the foliage. The trees and shrubs appear solid and dense – there's not a single "sky hole" in the foliage – and the textural details appear unnatural and "painted on."

## THE SOLUTION

**A** good watercolor painting of trees is one that looks fresh and spontaneous. The way to achieve this quality is to translate all those complex shapes and textures into a simpler language. In other words, use descriptive brushwork to *suggest* details, instead of laboriously "reporting" them.

In *The White Gate* by Lucy Willis (opposite) we again have a complex mass of trees and shrubs. The foliage *looks* like foliage, yet how simply and directly

it is painted. There's also a pleasing sense of light and air, which is missing in the problem painting.

■ **Variety of shape** Make a habit of studying the characteristic shapes of various species of tree, taking particular note of their proportions and growth habits. Notice, for example, how tall and how wide the canopy of a tree is in comparison to its lower trunk. A common fault is to make the canopy too small and constricted, which results in the dreaded "lollipop" effect.

■ **Texture** Instead of trying to paint individual leaves, let your brushstrokes suggest them. In *The White Gate* Lucy Willis has used small flecks and dabs of paint which indicate clusters of foliage without appearing stilted.

■ **Light and shade** Trees are three-dimensional, not flat, as they are so often portrayed. Observe the direction the light is coming from, and paint the side of the tree facing it with lighter, warmer greens than the shadow side. Note also how the interior of the tree is often much darker than the branches reaching out to the light.

■ **Sky holes** One important factor that is often overlooked is the gaps between the branches. Even when a tree is in full leaf there are lots of small gaps through which the sky is visible, particularly around the edges. In the problem painting every inch of the paper is covered in paint; in Lucy Willis's painting, tiny gaps of white paper create a shimmering effect which gives the whole scene freshness and sparkle.

Strategic "skyholes" make the trees look more delicate and graceful.

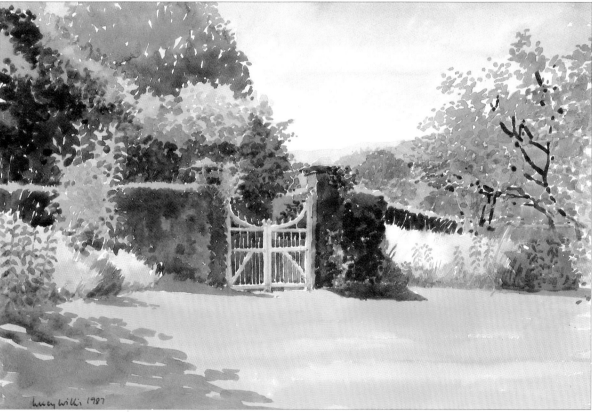

*The White Gate* by Lucy Willis

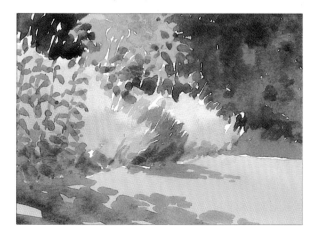

Trees and foliage are massed into groups of light and dark value so that each one registers strongly against the other. Warm and cool greens built up with transparent glazes give the effect of sun shining through leaves.

■ **Be inventive** Watercolor is a highly expressive medium, and painting foliage lets you exploit your powers of invention to the full. Arthur J. Barbour's painting *Lone Boat* (below) was painted entirely with a natural sponge and watercolor, using the method described opposite. The sponge disperses the color with a stippled, broken effect which gives a lively impression of foliage without appearing to try too hard. Even the tree trunks are painted by lightly stroking with the ragged tips of the sponge. You could also try painting foliage with a flat bristle brush and dryish paint; this gives a rough, broken texture which reads as "leaves." Experiment with different techniques and painting methods – the point is to paint expressively, to capture what you *feel* about the subject, not slavishly to try to copy it.

*Lone Boat* by Arthur J. Barbour

A natural sponge is a handy tool for depicting the feathery texture of summer foliage. Here the artist has sponged with layers of different colors to create a variety of warm and cool greens.

## —— PAINTING WITH A SPONGE ——

Painting with a sponge gives you natural-looking foliage effects with great economy of means. Make sure to use a natural sea sponge, though: man-made sponges are too smooth-textured for applying paint. You'll find large, rough-textured natural sponges in some drugstores and hardware stores. Look for a sponge with plenty of rough, ragged edges on its surface; tear it into small pieces and you have a perfect tool for painting foliage and a whole range of other textures.

To make the sponge pliable, dip it in water, then squeeze it dry. If water is left in the sponge it will dilute the pigment, and the marks will be blurred. For the same reason, paint for sponging should not be too fluid. Use it straight from the tube or diluted with just a drop of water.

Try dipping the sponge into several shades of green at one time. Or dab one color over another to achieve stronger values in the shadow areas of the foliage. Experiment with the technique on scrap paper – aim to create a range of marks that vary from a solid imprint to a delicate drybrush effect.

For delicate foliage, use a stippling technique. Use the finer side of the sponge and tap it onto the paper very lightly, using a straight-up-and-down motion. One or two taps with the sponge are usually all that's needed – any more and the texture becomes too dense.

# *H*ow do you capture
## *the soft texture of animal fur*?

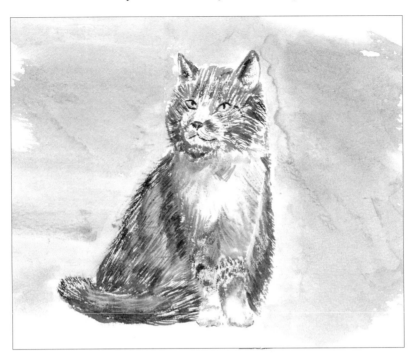

## THE PROBLEM

**A**nimals make delightful painting subjects but, unfortunately, they tend not to sit still for long. It can be very frustrating when your "model" suddenly gets bored and wanders off, leaving you with a half-finished painting, and for this reason many people prefer to work from a photograph of their pet. Generally, however, this is not a good idea because photographs tend to flatten form, distort colors and reduce textural detail. They also "freeze" the pose of the animal, and this often means that the finished painting, too, lacks life and movement. In the painting above, for example, the cat appears unnaturally stiff, like a paper cut-out which has been "stuck on" to the picture surface.

Rendering the soft texture of animal fur also presents problems for beginners. In this example, the student has used too many stiff lines and strokes, with the result that the cat's fur more closely resembles a porcupine's quills. This same mistake is often made when painting human hair: the novice painter attempts to render individual hairs, instead of suggesting the bulk of the hair in terms of soft masses.

## THE SOLUTION

**I**t may not always be easy, but painting an animal from life will in the end give you better results than copying from photographs. The secret is to choose a time when your pet is completely relaxed – perhaps when it is snoozing after a meal or basking in the sun – and then paint as quickly as possible.

In *Lucy Asleep* (opposite) artist Sally Michel has used the fluid properties of watercolor paint to capture the sleek, sinuous form of the cat and also the soft texture of its fur. While the cat napped, the artist quickly blocked in weak washes of Naples yellow and yellow ocher to establish the curled shape of the body. She then modeled the contours of the head and body with stronger washes, building up the major planes and masses much as a sculptor would. The black markings were added next, using light and dark washes of ivory black, well diluted. The finer details were left till last. Since speed is of the essence, this is the most sensible approach to adopt; the main thing is to capture the characteristic shape and gesture of the animal first, because this is what gives character to the "portrait." Then, even if the animal changes position, you can fill in the finer details such as the nose, claws and the whiskers without too much difficulty.

■ **Work wet-in-wet** To capture the smooth, downy appearance of animal fur, use fast, flowing strokes and think in terms of masses rather than lines. Work up gradually from the palest values to the darkest, allowing each succeeding wash to blend into the previous one just before it dries, so that fuzzy edges form. Finally, draw in just a few of the fine, long hairs using the tip of a very fine brush.

*Lucy Asleep* by Sally Michel

This detail shows how the soft texture of the fur is created by brushing in the darker colors while the lighter ones are still damp. If a color is too dark, or spreads too far, it can be gently blotted with a tissue or soaked up with blotting paper.

# *H*ow do I capture the atmosphere of a landscape in winter*?*

## THE PROBLEM

**I**t's too cold! That's the excuse most of us use for not painting winter scenes on the spot, but I always feel that you can't capture the mood of the day unless you get out there and experience it.

The snow scene above was probably painted using a photograph or a Christmas card as reference. The tell-tale signs are a uniform blanket of pristine white snow and an over-bright sky. Also, the snowflakes appear clumsy and stilted because the student has painted each one separately with white paint.

## THE SOLUTION

**P**eople tend to avoid painting snow scenes on a cloudy day because they imagine they will be "dull." Yet a winter landscape on a cold, bleak day has a stark beauty all its own, in which the skeletal shapes of the trees make dramatic patterns against the snow and the sky.

*Snow Lane* (opposite) is highly effective in conveying the hushed stillness of a snow-covered landscape under a threatening sky. Using a limited palette of subtle grays and browns, plus the white of the paper for the snow, Keith Andrew composes his picture in terms of light and dark value patterns which, in their austerity, convey the bleakness and coldness of winter. We also sense the power and grandeur of nature, represented by the tiny, muffled figure of the old man set against the great, dark tree.

▦ **Value contrasts** The beauty of a snow scene is that everything is reduced to striking patterns of light and dark. Look for opportunities to use strong value contrasts, such as the dark shapes of trees, walls or buildings against the snow. On an overcast day, the value of the sky is darker than that of the snow-covered land – an interesting reversal of the normal arrangement. In *Snow Lane* notice how the darks of the trees and the white of the snow are intensified through contrast with the middle-value gray of the sky.

▦ **Harmonious colors** Use color to convey a mood and produce a harmonious image, rather than creating an exact replica of the scene. In his painting, Keith Andrew uses a restricted palette consisting of sepia, burnt sienna, ultramarine and light red. This restrained use of color emphasizes the impression of coldness and stillness.

*Snow Lane* by Keith Andrew

Pale values and blurred outlines
convey atmosphere and mystery.

Spattered masking fluid can be
freely painted over, then rubbed
off to reveal delicate
"snowflakes" in the dark sky.

# *N*o matter how hard I try, I can't get water to look like water!

## THE PROBLEM

**W**hy is it that paintings of water so often go wrong? Undoubtedly the main cause of failure is over-elaboration. The problem is that, when you really start to look at it, even the calmest water is constantly moving and changing. Ripples and eddies come and go; reflections stretch and shrink; patches of light wink on the surface and disappear. The inexperienced artist pounces on every one of these elusive details, like a kitten chasing butterflies, and ends up getting hopelessly confused. Worse still, with every stroke of paint applied, the painting becomes more cluttered, and what started out as a river or a lake begins to look more like a patterned carpet.

Another common error demonstrated in the painting above is that of making the river seem to flow uphill! First, the angle where the river curves around the bend is too wide: it should be much flatter and sharper. Second, there's no sense of perspective in the ripples on the water's surface because they are all the same size: they should become smaller, darker and closer together as they recede into the distance, in line with the laws of perspective.

## THE SOLUTION

**T**he secret of painting water is to "edit out" all the superfluous details and go for the bigger masses of value and color. In *Boats on the River Douro* (opposite) Lucy Willis leaves much of the paper bare and puts in just a few telling ripples and reflections, which are all that's needed to spell "water."

■ **Smooth strokes** You've probably heard the saying "Less is more," and nowhere does this apply more readily than in the painting of water. Achieving the smooth, glassy look of water requires surprisingly little effort; often a few sweeping strokes with a broad brush on damp paper are enough to convey the effect you want. Yet beginners often seem to think that "there must be more to it than that" and insist on putting in a few extra streaks and ripples here and there for good measure.

■ **Be decisive** Whether you apply your colors to dry paper or damp paper is a matter of preference, but here's one important piece of advice: choose your colors with care and apply them with confidence. The more decisively and simply you paint water, the wetter it looks, so try to work with large brushes which discourage the habit of fiddling and prodding, and use plenty of water to facilitate smooth, even strokes. Mix your colors carefully on the palette and test them on scrap paper before committing yourself, remembering that they should appear quite dark in value to allow for the fact that they will fade a lot on drying.

Smaller, denser ripples indicate water receding into the distance.

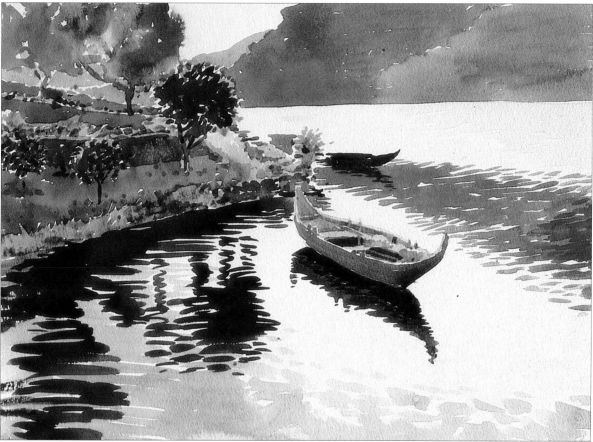

*Boats on the River Douro* by Lucy Willis

Ripples are larger and more broken in the foreground. Expressive brushstrokes give a sense of movement.

Sharp contrasts of value between water and reflections give a "glassy" look to the water.

# *How do I portray rapid water effectively?*

## THE PROBLEM

The problems involved in painting water are multiplied about 10 times when it comes to painting rapids, waterfalls and fast-moving streams. There's so much action going on, it's difficult to know where to begin.

The painting above demonstrates a number of common errors made by beginners. First, the river appears "frozen," like a movie that's suddenly stopped, because the student has used his paint too thickly and with far too many fussy brushstrokes. Second, the water appears to be on a flat, vertical plane because there is no reduction in the size of the brushstrokes as the water recedes into the distance. Third, the student has not paid attention to the subtle colors of water: he resorts instead to a stereotyped blue which looks completely unnatural, with thick globs of white paint for the foam.

## THE SOLUTION

*Moonriver, Ontario* by Ronald Jesty (opposite) demonstrates how a looser, more direct approach can be far more effective in rendering rapid water. In this version the white of the paper does much of the work in conveying an impression of water foaming and churning over the rocks: surprisingly few strokes of color are needed to complete the image.

■ **Keep it simple** Remember that rapid water looks more realistic when it's understated. Concentrate only on the major lines of motion – the ones that capture the essence of the water's movement. Don't allow yourself to be distracted by unimportant details which will clutter up the picture and destroy the illusion of movement.

■ **Confident brushwork** To paint fast-moving water well requires fast-moving brushstrokes. One deft squiggle can convey far more than any amount of hesitant goings-over, so take your courage in both hands and allow the brush to follow the movements of the water. Notice how Ronald Jesty uses strong, rhythmic brushstrokes to impart a sense of movement and encourage the eye to follow the progress of the water as it rushes over the rocks.

■ **Effective contrasts** Often the best way to emphasize something is by contrasting it with its opposite. In *Moonriver, Ontario* note the contrast between the water, which is painted with thin paint and very light values, and the surrounding landscape elements which are painted with more definition and stronger values. These dark values and solid shapes make the water appear more fluid and fast-flowing through the confident use of contrast.

Surrounding solid shapes make
the water appear more fluid
through contrast.

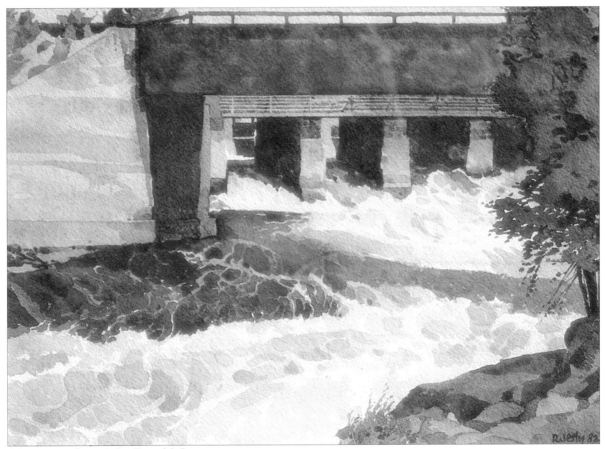

*Moonriver, Ontario* by Ronald Jesty

Note the water's subtle color
and how the white of the paper
is used to represent churning
foam. Strong calligraphic
brushstrokes capture the
churning movement of water.

*I love to paint trees in winter,
but my efforts often look stiff and clumsy.*

## THE PROBLEM

In the landscape painting above, the student has created quite an attractive harmony of color, in which pinks, mauves and greens are woven throughout. Against this harmonious backdrop, however, the tree sticks out like a sore thumb. It looks awkward and clumsy because it has been painted with much too large a brush: the branches are uniformly thick instead of tapering toward the ends, and because there are no fine twigs at the ends of the branches, the tree looks dead. Lack of observation is the main reason for failure here. There is no indication of where the light is coming from, so the tree looks flat instead of round, and there is little or no indication of the texture of the bark.

It is worthwhile noting also that the composition would have been much improved if the tree had been moved a little farther into the picture. As it stands, the picture looks off-balance because it is weighted too heavily to the left.

## THE SOLUTION

In *Dead Tree* (opposite) Keith Andrew exploits the dramatic shapes of the gnarled and twisted branches against a wintry sky. Even though this tree is actually dead, it looks more lifelike than the tree in the problem painting! Let's examine the reasons for the success of this picture.

■ **Texture and form** By carefully observing the way light falls on the trunk and branches, Keith Andrew manages to create a strong sense of form and solidity in his tree which is missing in the problem painting. Strong contrasts of light and dark also convey an impression of the bleak, cold light of winter. Notice how the artist uses rugged drybrush strokes to suggest the texture of peeling bark.

■ **Foreshortening** To create a realistic, three-dimensional tree it is necessary to depict branches growing toward you and away from you, as well as sideways. In *Dead Tree*, see how the artist foreshortens the branches nearest to us. Beginners are prone to avoid foreshortening, and as a result, their trees have a flat, fan-like appearance. There's nothing difficult about foreshortening – you just have to trust what your eyes tell you.

■ **Proportion** One important thing to consider is the length and spread of the branches in relation to the height and width of the trunk. Beginners often underestimate the size of the upper part of the tree, as has happened in the problem painting. As Keith Andrew's version clearly shows, from the base of the tree to the point where the main branches begin to spread out is often only one quarter of the total height of the tree.

Another common mistake is in making the twigs and branches too thick and omitting the delicate twigs at the outer edges of the tree. This happens when the artist simply runs out of room for them. To avoid the problem, make a light outline drawing of the general shape of the tree. This will make it easier for you to determine how thick a branch should be at a certain point.

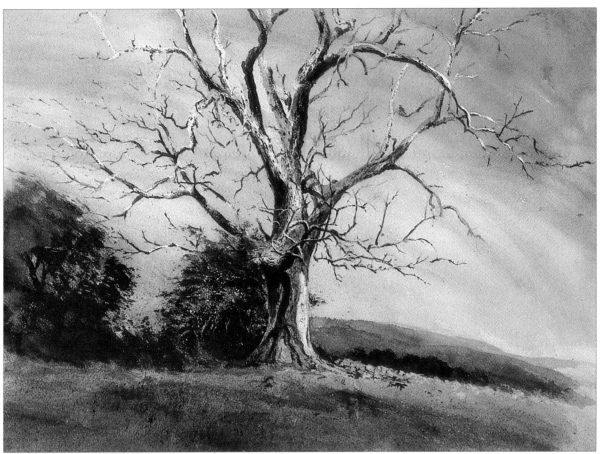

*Dead Tree* by Keith Andrew

The pale, dead branches were painted with masking fluid in the first stages. This was removed when the painting was completed, and the texture of peeling bark was indicated with drybrush strokes. Quick, light strokes with a brush tip indicate fine twigs.

Foreshortened branches make the tree look three-dimensional.

Here the artist accentuates the delicate tracery of dark branches against the snow. A very thin brush, sometimes called a rigger brush, is useful for painting delicate lines such as these. Notice how pale drybrush strokes indicate the fine twigs around the outer edges of the tree.

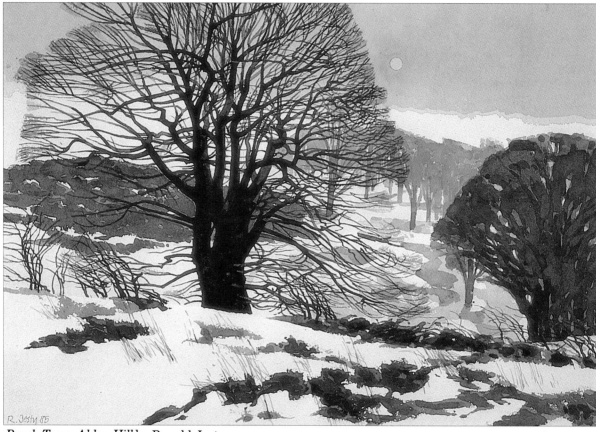

*Beech Trees, Aldon Hill* by Ronald Jesty

■ **Design** Where a single tree is to be the focal point of the picture, it's important to place it well. Keith Andrew places his tree just off center, with the branches spreading gracefully out across the picture. This gives balance and stability to the image, as well as greater dramatic impact. Compare this to the problem painting, in which the tree is cramped in one corner and the rest of the picture is empty.

■ **Tree anatomy** There are, of course, many different species of tree, and no two trees are the same. But there are certain anatomical points to watch out for when painting trees, and by becoming familiar with them you will avoid the stiff, awkward-looking trees that spell "amateur." Let's look at a typical

deciduous tree, such as an oak or a maple, and at how Ronald Jesty has approached the subject in his painting *Beech Trees, Aldon Hill* (above).

First of all, the trunk doesn't shoot straight out of the ground like a telegraph pole; normally some of the roots are visible. The main limbs leave the trunk at an angle of roughly thirty degrees. No two limbs leave the trunk directly opposite one another, or at the same angle, so watch out for this occurring in your painting.

The trunk becomes narrower as it divides off into limbs, until finally, at the top, there is no trunk at all: only a split into the last two limbs.

The limbs, in turn, split into smaller, thinner

Notice how the trunk is graded from light and warm colors at the base to dark and cool at the top; this gives the illusion of light reflecting up off the snow. Subtle gradations like these make a watercolor painting "glow" and give it life.

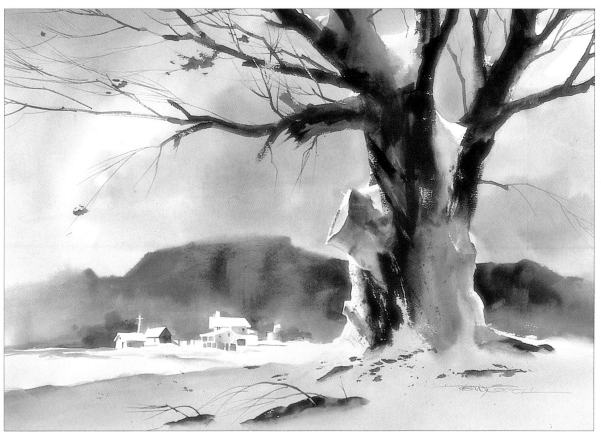

*Snow Valley* by Tony Couch

branches. Again, the branches come off the limbs in a staggered form – never directly opposite one another. The angle of the branches is important. At the top of the tree they leave the limbs at about a thirty-degree angle, but as they descend the tree they become more spaced out, and the angle becomes wider until, about two-thirds down, the branches are horizontal. At the same time, the length of the branches varies, gradually becoming longer as they descend the tree.

Last come the twigs, which are thinnest and fan out from the ends of the branches. These fine twigs are important, because without them the tree appears dead. However, trying to paint every indi-

vidual twig is both impossible and undesirable. It's better to *suggest* the twigs by applying feathery dry-brush strokes in a paler value.

**Modeling** Where a tree is seen close up, as in Tony Couch's painting *Snow Valley* (above) it will need to be modeled with light and shade to show the roundness of the trunk. Make a note of where the light is coming from, and make that side lighter than the other side. In watercolor it is a simple matter to achieve the required roundness of form in a few strokes. Start at the base of the trunk and move upward, beginning with a pale allover wash. While this is damp, paint the shaded side a darker value, allowing the two values to blend where they meet.

# *T*he objects in my still life don't look rounded. Where am I going wrong*?*

## THE PROBLEM

Square-edged forms have clearly defined planes of light and shadow which are easy to recognize. But when light strikes a rounded object, the transition from light to shadow is gradual, almost imperceptible, and consequently is much more difficult to render successfully.

In the still-life painting above, the student has made the common mistake of using watercolor in the style of an opaque medium – that is, by mixing and placing first one area of color, then another, until a patchwork of colors and values is built up. This method works fine in oils, which stay wet long enough for you to be able to blend colors together with a brush, but in a fast-drying medium such as watercolor, it can lead to a stilted effect with streaks and ridges. In this example the light and shadow planes are crudely rendered and the impression of softly rounded form is lost.

Another mistake demonstrated here is the failure to observe shapes correctly. The elliptical shapes at the tops of the jugs are too wide, as if seen from above, whereas the bases are too flat.

## THE SOLUTION

Painting rounded forms in watercolor is actually quite simple. Instead of painting tight, rigid sections of light and shadow, grade one value into another by working on damp paper so that the colors flow softly together without any hard edges. Apply the lighter values first, cutting around the brightest highlights. While the base wash is still damp, begin to float in the adjacent darker values. The two will fuse together and create an illusion of roundness.

In *White Cup and Saucer* (opposite) Lucy Willis has portrayed the rounded forms of the subject with great economy of means, using the method just described. The result is fresh and direct, and the shapes are softly rounded.

■ **Reflected light** If you look carefully at the shadow side of the object you are painting, you will see a small sliver of light, usually near the outer edge, which bounces into the shadow area from nearby objects or from the surface on which the object is standing. Attention to small details like this increases the sense of form and also makes a painting sparkle with light.

■ **Light direction** Light striking an object from the front tends to flatten form, whereas light coming from one side will do much to enhance the impression of form. So when setting up a still-life group, try to arrange the lighting so that it falls to one side of the group and slightly in front; this will create a strong pattern of lights and darks which clearly defines the forms and makes the job of painting that much easier.

Flecks of bare paper make sparkling highlights.

When the paper is wet, paint diffuses to create a soft edge which gives the illusion of gently rounded form.

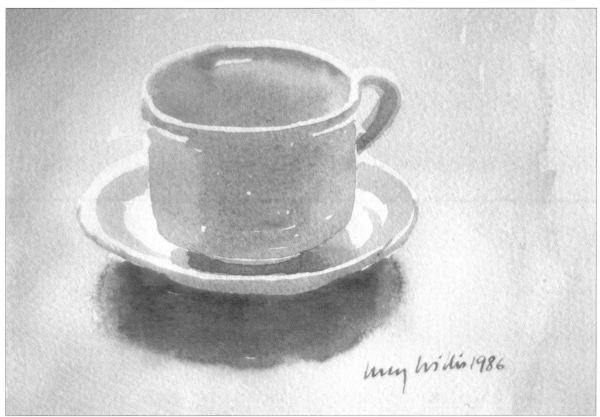

*White Cup and Saucer* by Lucy Willis

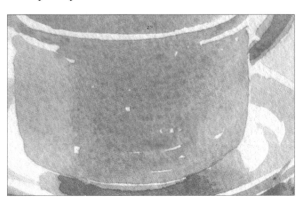

Subtle hints of reflected light in the shadow area add luminosity.

*I find old and weathered subjects like
this building fascinating. How can
I render their textures more effectively?*

## THE PROBLEM

**B**uildings, boats, trees, fences and rocks all make fascinating painting subjects, especially when they've grown a little weatherbeaten due to the ravages of time and exposure to the elements.

For the watercolor painter, the challenge lies in knowing how to render a convincing illusion of weathered textures, without overworking the painting. As the painting above demonstrates, beginners often have a problem with this. The tendency is to try too hard for a "photographic" impression, with the result that the painting becomes over-burdened with detail and all spontaneity is lost.

In this case the student has painstakingly rendered just about every brick and tile on the building. Not only does this look amateurish; it also leaves nothing to the viewer's imagination.

## THE SOLUTION

**S**uggestion is the key to rendering complex textures in watercolor. Why go to the trouble of laboring over minuscule details, when a few deft brushstrokes can convey all you want to say – and do so far more poetically?

In *Behind the Cow Shed* (opposite) Keith Andrew uses the traditional techniques of glazing and drybrushing to convey the crumbling texture of the weatherbeaten walls and the wooden doors and shutters of the cottage. A sprinkling of spattered paint adds the final touch, indicating the pitted, lichen-covered roof and walls. All of these details are understated, yet we are left with a convincing impression of an old, abandoned cottage at the mercy of the elements.

Aside from these traditional techniques, there are other, more innovative texturing methods that you can use, such as lifting out, wax resist and salt resist, which are described on the next page. A word of warning, though: such methods should be used sparingly; otherwise they can all too easily become slick and mechanical.

▓ **Sedimentary colors** Sometimes the paint itself can suggest mottled and pitted textures. Certain pigments, such as burnt sienna, manganese blue and ultramarine, settle into the paper with a pleasing granular appearance, due to the presence of sediments in their make-up. The natural texture of the paint is perfect for subtly suggesting gritty textures such as sand and old stone.

▓ **Paper texture** The kind of paper you choose will play a part in the textures you create. For instance, drybrush texturing is especially effective on rough paper, which catches at the paint and breaks it up. On the smooth, non-absorbent surface of hot-pressed paper, watercolor has a tendency to puddle. Take advantage of this by swirling the paint with your brush, or impressing with a sponge or crumpled tissue to create the texture of rocks or dense foliage.

▓ **Scraping out** can be done with any sharp item, from a knife to your fingernail. Sharp, clean lines are created by scratching into dry paint; a blunter edge,

*Behind the Cow Shed* by Keith Andrew

Scumbles and glazes of color suggest the crumbling surface of walls without overstatement.

Lightly spattered masking fluid suggests flaking stonework.

Drybrush strokes suggest old, decaying wood.

such as the end of your paintbrush, can be used to scrape softer lines and marks out of semi-dry paint.

■ **Wax resist** To create pale, broken lines in a dark wash, such as when painting a stone wall, try the wax resist method. Lightly draw the lines with a white candle or wax crayon on rough paper. The wax will resist subsequent washes. When the paint is dry you can remove the wax by placing absorbent paper over the area and pressing with a cool iron.

■ **Salt resist** To create the texture of lichen-covered walls, sprinkle a few grains of coarse salt into semi-wet paint. When the paint is dry, brush off the salt to reveal a pale, delicate texture where the salt granules have soaked up the pigment.

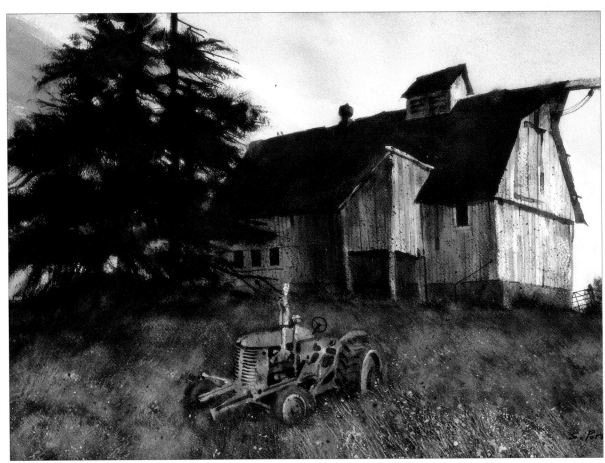

*Barn off no. 5 Road* by Stan Perrott

There's a pleasing quality about the texture of old weathered wood which modern materials lack. Drybrush strokes and light spattering are used here to capture the ramshackle character of the barn and the old abandoned tractor.

## TEXTURING TECHNIQUES

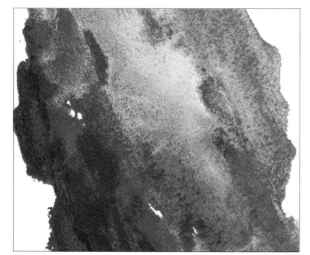

Sedimentary colors

Texturing on rough paper

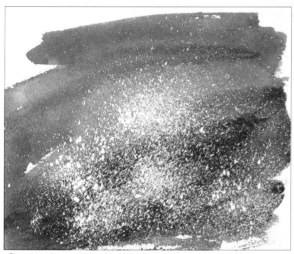

Spattering with masking fluid

Scraping out

Wax resist

Salt resist

# *I find painting faces in watercolor difficult – especially eyes and mouths.*

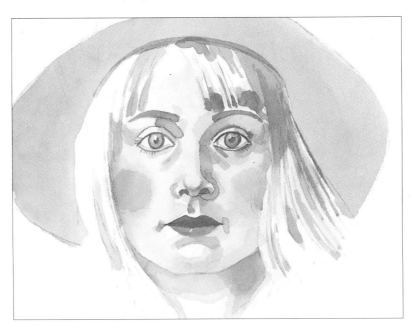

## THE PROBLEM

One of the commonest mistakes in portrait painting is to render the facial features too tightly. The tendency is to draw outlines of the eyes, nose and mouth and then fill them in with color, often painting the surrounding skin tones last of all. Because each part of the face is tackled separately, and not related to the whole, the portrait begins to look wooden, more like a cartoon than a painting. In the portrait above, for example, the mouth appears flat, hard and doll-like, and the eyes have an unnatural, staring quality.

The eyes are the most prominent feature of the face, but beginners often give them *too* much emphasis: notice the hard outlines around the eyelids. In addition, the colors are too strong and artificial, particularly for the eyes and mouth, and the shadow areas are too hard-edged.

## THE SOLUTION

The eyes, nose and mouth are not "stuck" onto the surface of the face, as they appear to be in the problem painting. The bones and muscles that lie beneath the skin are all interconnected, so painting a smiling face, for example, is not just a matter of making the corners of the mouth turn up; you must also make the eyes, cheeks and jaw smile.

The best way to approach painting faces is to work from the general to the particular, rather as a sculptor begins with roughly-hewn shapes, from which he gradually carves out the smaller details.

In *Portrait of a Young Girl* the girl's face is fresh, mobile, and lifelike. Rather than finishing the eyes and then moving on to the nose, Sally Launder worked over the whole face at once. That way, she could better judge the relationships between the features and make any necessary adjustments as she went along.

**Eyes** are not difficult to paint once you understand how they are constructed. The eye is not a flat disk – it is basically a sphere which "sits" inside the upper and lower eyelids, not resting on their edges as in the problem painting. Also, the whites of the eyes are not a uniform, stark white. Because the eyeball is round, the whites of the eyes pick up shadows and reflections from their surroundings.

**Mouths** As mentioned above, the fatal error when painting mouths is in drawing an outline and filling it with color, which gives the mouth a flat, pasted-on appearance. The correct technique is to "sculpt" the form of the mouth, creating soft masses of light and dark value that blend softly together. In the solution painting see how the edges of the mouth blend naturally into the surrounding flesh, with just a hint of crisp edge where the top line of the upper lip is caught by the light.

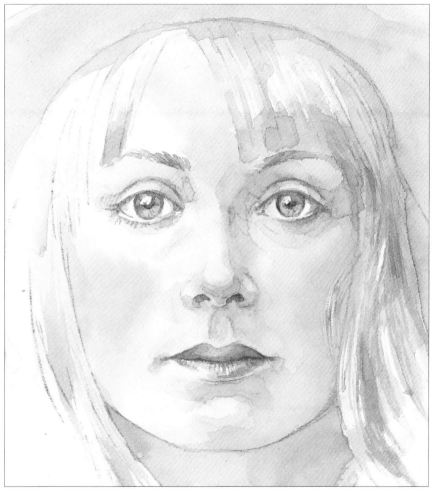

*Portrait of a Young Girl* by Sally Launder

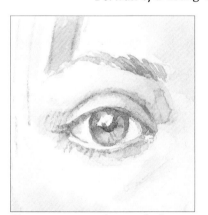

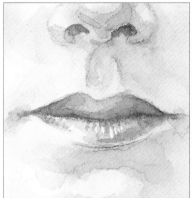

Transparent washes and glazes give an impression of luminosity in the eyes. A subtle use of shadow indicates that the eyelid folds over the eyeball.

The color of the lips is delicate and understated. Softness and mobility are achieved through combining both washes and glazes and lost and found edges.

Delicate skin tones are achieved by blending colors wet-in-wet and not overemphasizing shadows.

# *P*ainting objects made of metal and glass is so difficult – how do you achieve that shiny reflective look*?*

## THE PROBLEM

**M**any people avoid painting metal and glass objects – it seems too tricky a subject to handle, and in watercolor, one mistake might ruin the whole thing.

In the painting of a metal coffee jug above, the student has allowed himself to be overwhelmed by the apparent complexity of the shadows, highlights and reflections in his subject. He has used a good basic palette, but a kind of panic has set in, and the end result is a confusion of disjointed shapes and unrelated colors – the jug doesn't appear "shiny" at all.

## THE SOLUTION

*The Dinner Table* by Lucy Willis (opposite) offers a bold, direct approach to painting reflective objects, and it works beautifully. Here we have what is in fact a complex subject – a highly polished table set with gleaming silver, glass and cutlery, all reflecting the strong light from a nearby window. The overall effect of the picture is stunningly realistic, yet close scrutiny reveals how simply it is painted.

■ **Select and simplify** Creating a convincing impression of reflective objects first requires careful observation of your subject. Then you need to be able to simplify what you see, and to include only the main shapes and values, because too much detail quickly destroys the illusion of a smooth, light-reflecting surface. Painting glass and metal objects is much like painting water – the less detail you put in, the more convincing the effect.

In *The Dinner Table*, for example, note how the table is painted with broad, smooth washes and crisp glazes. Similarly, the forms of the objects on the table are built up with firm, decisive strokes of color, with not a fiddly detail in sight.

■ **Value contrasts** Glass and metal are highly reflective, so shadows are strong and highlights very intense. Therefore strong contrasts of light and dark value are the key to painting glass and metal objects. So use, rich darks in the shadow areas, and leave areas of white paper for the brightest highlights.

In Lucy Willis's painting, the range of colors is narrow, but there's a positive symphony of lights and darks which give sparkle and zest to the picture. The reason the highlights appear so striking is that they are surrounded by dark values. We can never hope to convey in paint the brilliance of light in nature; our only recourse is to cheat a little by placing light areas next to dark ones, so that the light appears brighter through contrast.

Glazes and graded washes indicate the highly polished surface of the table.

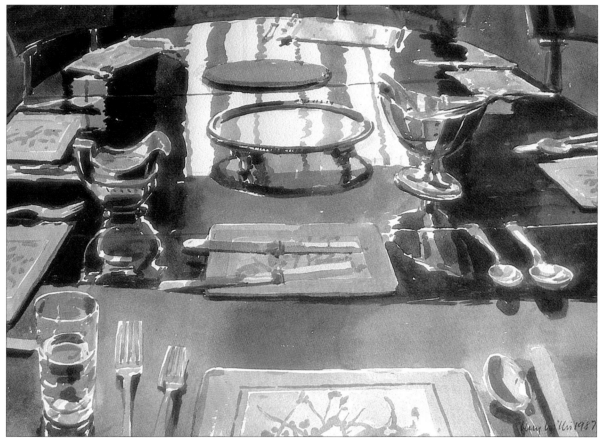

*The Dinner Table* by Lucy Willis

Sharp contrasts of light and dark value give an impression of shiny metal.

Slivers of bare paper create crisper highlights than white paint can.

*In this painting I've tried to capture the effect of early morning mist on the river, but somehow it doesn't quite work.*

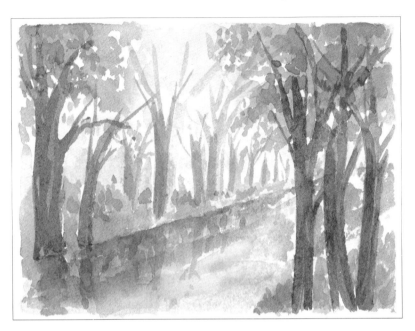

## THE PROBLEM

**A** landscape shrouded in mist is a thing of ethereal beauty, in which colors are softened and the forms of the land melt into pale, ghostly shapes. A subject like this offers you a golden opportunity to switch off the purely analytical side of your brain and give free rein to your intuitive responses, both to the subject and to the watercolor medium.

The reason the painting above doesn't quite work is that it fails to capture the *spirit* of a misty morning. The impression of mistiness is lost because the student has used too much detail and too many hard edges and intense colors. The problem stems, of course, from becoming too closely involved in the subject and trying too hard to "get it right." Had the student aimed instead to capture his first impression of the scene, quickly and spontaneously, his painting would have been far more successful.

## THE SOLUTION

**I**nstead of faithfully copying what you see, why not live dangerously for once and allow the paint itself to suggest the transient beauty of nature? Because mist is actually water vapor suspended in the air, it follows that watercolor has a natural affinity for capturing its effects. All you have to do is develop the confidence to let your colors flow freely, wet-in-wet, and to be ready to capitalize on those "happy acci-

dents" that are part and parcel of the joy of watercolor painting.

That's not to suggest, of course, that painting misty landscapes is easy. There's a certain skill involved in achieving the right degree of softness of form and color, while not allowing the picture to dissolve into a meaningless blur.

In *Misty Morning* (opposite) Jo Skinner has achieved a misty effect by using the wet-in-wet technique to soften the forms, particularly in the distance. But note how she has introduced stronger values and colors in the foreground to give the picture a firm anchor and accentuate the softness and mystery of the trees in the far distance.

■ **Techniques** In watercolor you can create a hazy effect by applying color to damp paper and allowing the forms to blur at the edges. Or you can work on dry paper, using a small, wet sponge to soften those areas where a misty effect is required.

■ **Gradations of value** It's a good idea to start your picture at the horizon, keeping the forms pale and indistinct. Work gradually toward the foreground, steadily strengthening the values and intensifying the colors. The contrast between the strong values in the foreground and the weak ones in the distance will accentuate the illusion of depth and space. Allow the painting to dry before adding the sharpest foreground accents.

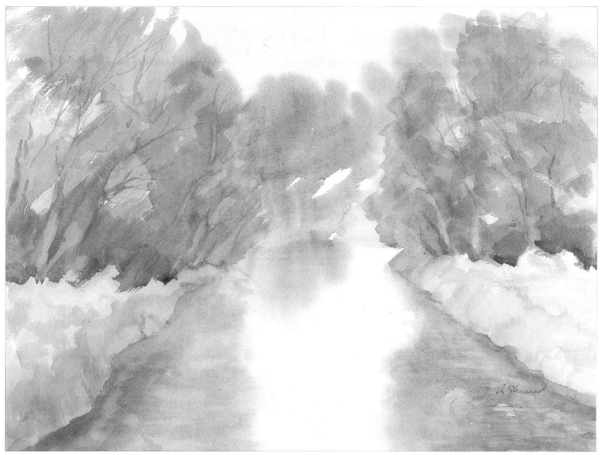

*Misty Morning* by Jo Skinner

Colors applied to wet paper create soft, misty effects.

Fog acts as a veil on the landscape, reducing color and value contrasts. This effect is achieved by using subdued, harmonious colors and closely related values.

*No matter how enthusiastic I feel about a scene, somehow that "inspired" feeling doesn't come through in my painting.*

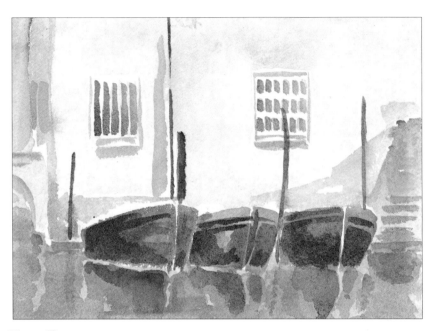

## THE PROBLEM

If you've ever been coerced into looking at a friend's collection of holiday snapshots, you'll know how easy it is to turn even the most magical scene into a run-of-the-mill picture!

When we first begin painting, we tend to look at things pretty much as a pocket camera does: we faithfully "copy" the subject, but we don't interpret it in a personal and expressive way.

The scene above was painted in the enchanting city of Venice, which has been an inspiration to countless artists over the centuries. Yet the picture fails to inspire us, because the composition and viewpoint are safe and predictable, the colors are dull, and there is no feeling of light falling on the subject. The artist isn't telling us anything about how he feels about his subject, so we don't feel anything either.

## THE SOLUTION

It takes more than merely recording facts to infuse a painting with life. You must first of all pinpoint what it is that attracts you to a particular scene, and then orchestrate everything in the picture so as to put that across.

*Reflections of Venice* (opposite) demonstrates how a fresh and unusual approach can create a striking image which makes us look anew at a familiar subject. We are used to seeing paintings and photographs of Venice that show its grander side, but this painting stops us in our tracks because it gives us a different, more intimate glimpse of this lovely city.

The artist, Geoff Wood, has a particular fascination for painting reflections in water. He also loves Venice, and these twin passions come through loud and clear in his study of a quiet canal with its limpid reflections of pink buildings and moored boats.

■ **Expressive viewpoints** Don't opt for the safest, most obvious viewpoint; choose one that expresses your feelings about the subject. For example, a solitary, distant building placed in a vast landscape can evoke an atmosphere of loneliness and isolation, whereas a close-up view of a flower allows you to express something about its color or the delicacy of its petals. Look at your subject from different angles to see which aspect clicks with you.

■ **Choosing a subject** Often a painting fails because we've set ourselves an impossible goal. We trudge off into the countryside in search of some idealized "perfect spot" for painting, only to return home empty-handed at the end of the day feeling like the angler who didn't get a catch. Yet it's the simple everyday things, right under our noses, that often make the best paintings. If you want your paintings to be inspiring, paint what interests you, not what you think you ought to paint. Painters who are keen gardeners, for example, will find a wealth of inspiration in the greenhouse or potting shed as well as in the garden. Perhaps you have a favorite room in the house – one that always catches the sun or is filled with fond memories. Why not paint it? Because it is something you love, you will instinctively put more of yourself into the painting.

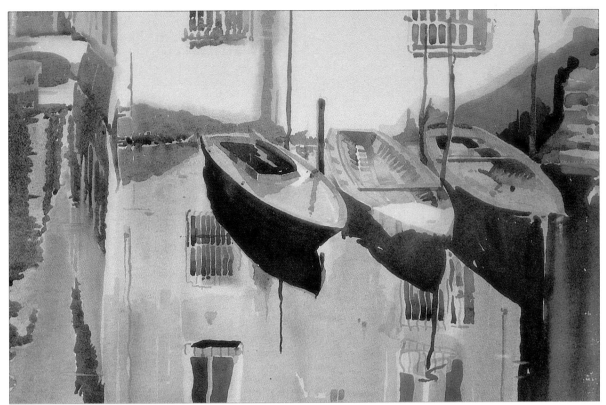

*Reflections of Venice* by Geoff Wood

*Loch Duich* by David Bellamy

Interpreting your subject often means having to think laterally: instead of "copying" what you see, use your creative skills to translate what you see into a more powerful image. In this painting, for instance, David Bellamy evokes an eerie, almost sinister atmosphere by reducing all the colors in the landscape to shades of gray.

*Bougainvillaeas* by Jan Kunz

If you're attracted by the intricate forms of an object, or its coloring, move in close and make the subject fill the entire picture area. In this painting the artist moves in so close to her subject that the flowers become almost abstract and the effect is emphasized by the photo-realistic handling of detail and light and shade.

*The Worcester Cup* by Jacqueline Rizvi

Choose a viewpoint that brings out your feelings about a subject. In this painting Jacqueline Rizvi places the china cup alone amid a large expanse of background, evoking an atmosphere of quiet tranquillity. Muted colors and the soft reflection of the cup enhance the mood.

*The Blue Window* by Keith Andrew

Emphasizing the textural qualities of a subject can evoke a tactile response from the viewer as well as a purely visual one. In this painting the combination of a close-up viewpoint and strong directional lighting accentuates the texture of the weathered wooden window frame. The stark value contrasts within the frame add to the acute sense of loneliness and isolation.

# INDEX

Page numbers in *italic* refer to the
illustrations and captions

─────────────────────────────────────────────

# CREDITS

p3 Ronald Jesty. pp6-7 Clarice Collings. p9 Nicola Gresswell. p11 David Bellamy. p12 Stan Perrott. p13 Norman Bancroft Hunt. p15 Lucy Willis, courtesy of Chris Beetles Ltd, St James's, London. pp17-19 Stan Perrott. p20 (top) Lucy Willis, courtesy of Chris Beetles Ltd, St James's, London; (bottom) Stan Perrott. p21 Keith Andrew. p23 Sally Launder. p25 Moira Clinch. p26 Alex McKibbin. p27 Angela Gair. p29 Norma Wheatley. p30 (top) Pamela Kay, courtesy of Chris Beetles Ltd, St James's, London; (bottom) Lucy Willis, courtesy of Chris Beetles Ltd, St James's, London. p31 (top) Lucy Willis, courtesy of Chris Beetles Ltd, St James's, London; (bottom) Pamela Kay, courtesy of Chris Beetles Ltd, St James's, London. p33 Richard Akerman, courtesy of Felix Rosentiel's Widow & Son Ltd, London. p35 Paul Osborne. p37 David Bellamy. p39 Paul Osborne. p41 Sally Launder. p42 Angela Gair. p43 Lucy Willis, courtesy of Chris Beetles Ltd, St James's, London. p45 Moira Clinch. p.47 Keith Andrew. p49 Stan Perrott. p50 Ronald Jesty. p51 Richard Bolton. p53 Keith Andrew. p55 Ronald Jesty. pp57-58 Stan Perrott. p59 Ronald Jesty. p61 Stan Perrott. p63 Frank Nofer (collection of Mr & Mrs George Nofer). p64 (top) Charles Inge; (bottom) Pamela Kay, courtesy of Chris Beetles Ltd, St James's, London. p65 (top) Charles Inge; (bottom) Pamela Kay, courtesy of Chris Beetles Ltd, St James's, London. p67 Stan Perrott. p69 Lucy Willis. p71 Geoffrey Wood. p72 (top) Stan Perrott. pp72-73 (bottom) Lucy Willis, courtesy of Chris

Beetles Ltd, St James's, London. p73 (top) Tony Couch. p75 Richard Bolton. pp76-77 Paul Osborne. pp79-80 Pamela Kay, courtesy of Chris Beetles Ltd, St James's, London. p81 (top & bottom) Ronald Jesty. p83 Richard Akerman, courtesy of Felix Rosentiel's Widow & Son Ltd, London. pp84-85 Clarice Collings. p87 Alex McKibbin. p88 Norman Bancroft Hunt. p89 (top) Clarice Collings; (bottom) Leslie Worth. p91 Ronald Jesty. p93 Lucy Willis, courtesy of Chris Beetles Ltd, St James's, London. p94 Geoffrey Wood. p95 Lucy Willis, courtesy of Chris Beetles Ltd, St James's, London. p97 Joan Heston. p99 Lucy Willis, courtesy of Chris Beetles Ltd, St James's, London. p100 David Hutter. p101 Pamela Kay, courtesy of Chris Beetles Ltd, St James's, London. p103 Ronald Jesty. p104 Norman Bancroft Hunt. p105 Cathy Johnson. p107 Moira Clinch. p109 Stan Perrott. p111 Lucy Willis, courtesy of Chris Beetles Ltd, St James's, London. p112 Arthur J. Barbour. p115 Sally Michel. p117 Keith Andrew. p119 Lucy Willis, courtesy of Chris Beetles Ltd, St James's, London. p121 Ronald Jesty. p123 Keith Andrew. p124 Ronald Jesty. p125 Tony Couch. p126 Lucy Willis, courtesy of Chris Beetles Ltd, St James's, London. p129 Keith Andrew. p130 Stan Perrott. p133 Sally Launder. p135 Lucy Willis, courtesy of Chris Beetles Ltd, St James's, London. p137 Jo Skinner. p139 (top) Geoffrey Wood; (bottom) David Bellamy. p140 (top) Jan Kunz; (bottom) Jacqueline Rizvi. p141 Keith Andrew.